Isabel Leonard
10 Park Terrace
East Kilbride (May 1981.)

THE COMPLETE OIL PAINTER

The Complete Oil Painter

F. C. JOHNSTON <small>SGA, FRSA</small>

Illustrated by the author with additional work by
Theresa Johnston and William Vickers, <small>SGA</small>

Also by F. C. Johnston

To Start You Painting
Starting to Paint in Oils
To Start You Sketching
Sketching and Painting

Design by Oxprint

First published 1979 by
Macmillan London Limited
London and Basingstoke

Associated companies in Delhi, Dublin
Hong Kong, Johannesburg, Lagos, Melbourne,
New York, Singapore and Tokyo

Printed in Hong Kong

British Library Cataloguing in Publication Data
Johnston, Frederick Charles
 The complete oil painter.
 1. Painting – Technique
 I. Title
 751. 4'5 ND1471
ISBN 0 333 23652 1

Contents

Introduction

All who have taken up oil painting and who enjoy this rewarding pastime will agree that, particularly with sound and patient instruction, the rate of progress in the early stages is surprisingly rapid. Were there a graph recording the rate and standard of attainment, it would show a very steep climb. Unfortunately, after this initial flurry of success, the graph suddenly levels out to a plateau, and it seems that any further progress is a depressingly long time in coming. After considerable hard work, some of the barriers impeding progress are overcome and all goes well for a time, until the process is repeated and once again there is much aimless wandering on yet another, but slightly higher, plateau. All of which makes the potential summit of one's personal attainment extremely difficult to reach.

Having worked with many leisure-hour artists for a great number of years, I realise only too well how very frustrating and disappointing such a go–stop–go development can be, and it was a wish to help towards more constant and less intermittent advancement that prompted the writing of this book. Its purpose is to help change the bumpy path of erratic progress for one which is smooth, straight and leads gently but directly to the satisfying heights of true artistic development. It is intended for those who have already started painting in oils and made reasonable progress, but still need advice and encouragement to reach a higher standard. Essential groundwork which may have been missed is re-emphasised and every effort has been made to anticipate pertinent questions so that progress will be neither erratic nor halting.

My thanks go to the hundreds of leisure-hour artists whose company I have so much enjoyed and whose enthusiasm has largely provided the material for this book. Gratitude must also go to William Vickers for the use of his fine demonstration painting; to Elisabella Boki who must surely suffer from sore finger-tips from so much typing, and to my wife Theresa, for her valuable help and co-operation as artist-cum-secretary-cum-teagirl. If our combined efforts bring improvement to your paintings and the development of a personal style, we shall all be extremely happy.

1 Preparing for Progress

I have great admiration for the enormous enthusiasm and energy of those who paint as a pastime. The quality of their work often reaches a high standard of competence in spite of their time being limited by the pressures of home, business or family. Once this standard is reached, however, it becomes increasingly difficult to improve upon: it seems to be a case of so far and no further. The reason for such a stalemate is almost invariably that in the desire to get on with the exciting business of putting paint to canvas various short-cuts have been taken. This may cause a failure to appreciate problems or even be aware of them, which results in the tedious and hesitant process of attempting to overcome them, as they arise, during the course of the painting. Once the rhythm of the painting is lost it is extremely difficult to recapture.

If there is to be any real improvement it is essential to think beforehand of ways of converting the subject to be painted into terms which allow for both the potentialities and the limi-

Figure 1.
MAKING THE SKETCH
SUIT ITS FUNCTION
a An outline sketch is really useful only for establishing the composition, and less so when painting.

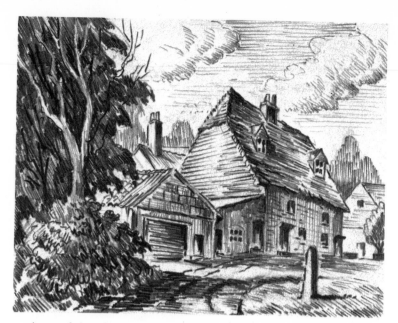

*b A tonal sketch, made with
careful and deliberate pencil-
strokes, is much more useful to
the painter although it is a
fairly lengthy process.*

tations of the chosen medium – in this case, oil paint. The best
way to achieve this and to prepare for problems ahead is to make
a working sketch before beginning to paint. Although such a
sketch may be quick and rough, it should capture the essential
'story' of the scene in clear and simple terms. It must be more
than a mere diagram, for not only should it give the shapes
which form the composition, it should also tell where the
various dark and light areas occur and convey much of the
general atmosphere. There should be an effect of depth, volume,
light and air. In other words the sketch should be full of
information which will be valuable when finally you start to
paint. It does not need to be a highly finished, precise drawing,
but rather a sensible and informative working sketch; it can
even include scribbled notes if these prove helpful.

The point can be made more clearly by looking at the
illustrations in *Figure 1*. The first shows a drawing done almost
as an outline, and although it is quite commendable from the
point of view of its composition and for the accuracy of the
various shapes, it is of no further use to the painter. It tells him
nothing of the source or quality of the light, the positions of
shadows, the time of day, which areas are light or which are
dark. Such a drawing, however carefully done, is of very limited
assistance. Obviously a great deal more information is needed,
not only to help in the painting itself, but to train the eye and
hand to search for essentials.

The second drawing in *Figure 1* would be of far greater help.
Here we have not only the essential elements of composition,
but also a clear indication of the various light, medium and dark
tones. These immediately give the feeling of depth, volume and
form. A closer look, however, shows that such a drawing with its
hundreds of sharp, crisp lines and its careful study of pencil

3

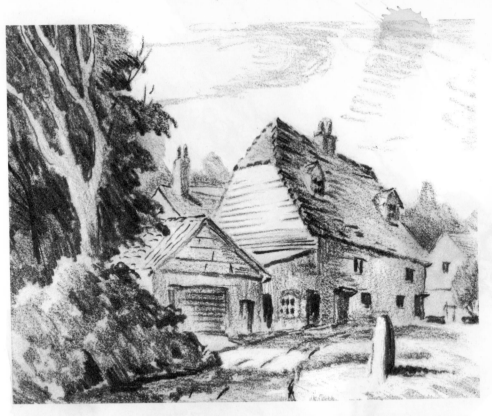

c A quick tonal sketch, made with a soft pencil held very flat, has the advantage of taking little time to provide essential information.

technique is hardly a quick preparatory sketch; it is a drawing almost worthy of a mount and a frame rather than being a quick piece of pre-picture planning. Although sensitive drawing which makes full use of the delightful linear qualities of the pencil is always to be encouraged, it is not really necessary at this stage. What is needed is a result which is similar, but something that will allow the essential facts to be put down very much more speedily.

This leads us on to our third sketch in *Figure 1*, which has all the necessary information, but by using the pencil with much more freedom it can be completed extremely rapidly. With a little practice such an example could be produced in about twenty minutes, which might easily save a couple of hours of painting time. Not only will it be to hand for reference during the painting, but having expressed the essential qualities of the scene in simple terms, one has automatically looked for and recorded the important main masses and areas, rather than any diagrammatic detail. In consequence the completed sketch looks very much like a black-and-white reproduction of a *painted* picture; its effect is similar to that of a painting made with a brush. It follows that a sketch made in this manner encourages one to think of the subject in painterly terms; it acts as a reminder that the subsequent painting will be in thick and creamy oil paint, which is not helped by an approach laying too much attention on rigid detail.

To make such a sketch use a pencil with a fairly soft lead – I normally use a 4B – and try to find one with a somewhat fatter lead than is usual. Sharpen it carefully (with a knife in preference to an automatic sharpener) so that its lead is about 1½cm in length, and hold it so that it sits comfortably across the palm side of the fingers. Then, with a gentle grip from the thumb, turn the hand over and you will find the whole of the pencil is almost flat to the paper (see *Figure 2*). In this way it is quite easy to make very broad strokes with almost the whole length of the exposed lead, rather than (if something approaching the more conventional pen-grip is used) just with the point. I also find it more comfortable if the pencil is not full-length.

Occasionally one may want to change the grip to indicate some small but important detail, but in the main a unified and painterly sketch will result if the pencil is held in the recommended flat position. A very gentle pressure will result in a fairly even covering with a light to middle tone and, by gradually increasing the pressure, areas of considerable darkness and density can be obtained. A few practice pieces will quickly give the feel of it. As a preliminary exercise, try blocking in a gradated scale of five tones – then try to increase it to eight.

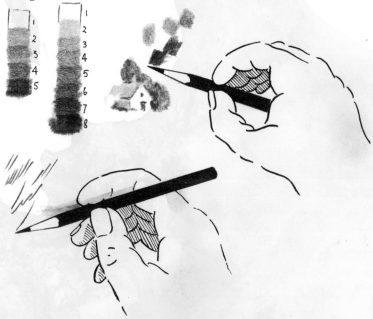

Figure 2 Holding the pencil flat allows for broad masses of tone to be established very rapidly. The more conventional pen-grip is used only for occasional detail.

A great advantage of this kind of speedy sketching is that it allows you to see quickly if the composition is proving successful without wasting too much valuable painting time. The viewpoint can be changed and a fresh sketch made in a much shorter time than it would take to alter and correct half-way through a painting. To 'repair' a painting that has gone wrong can be difficult and time-consuming, and to make a completely fresh start is equally frustrating.

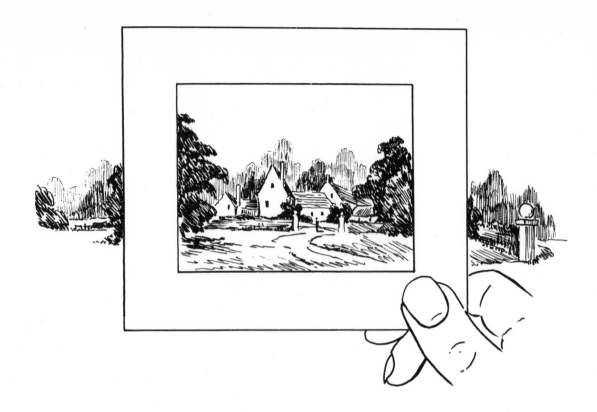

Figure 3 A simple viewfinder can be helpful in isolating a subject from a large mass of surrounding material.

Let us assume that you have found a pleasing subject, but are a little uncertain just how to place it on the canvas, or how little or how much to include. This is a common problem; many experienced and successful artists freely admit that they too find these early decisions very difficult. A simple viewfinder (*Figure 3*) helps a little, but it is the sketch which is of greater value, for it allows the eye to extend a little beyond any preconceived borders and relieves one of the worry, at this early stage, of making the scene fit precisely into any given rectangle. For this reason it is wise to use a sketch-pad much larger than you expect the sketch to be. As an example, many of my sketches are about 5in × 4in (12cm × 10cm) and I usually work on a pad measuring 10in × 8in (25cm × 20cm). Not only does this give good support for the hand, but it eliminates the temptation to make the sketch fit the paper, forcing a decision about positioning before the possibilities are tested. This is a decision to make a little later.

My suggestion is that you should look at the scene and find a simple and easy-to-draw object somewhere near the centre. It may be a gate-post, a door, a gable-end or in fact anything which can be recorded without difficulty to be used as an accurate measure against which all surrounding features can be judged. Such comparison is not only for size and position, but also for relative degrees of lightness or darkness (tone). Gradually

expand the sketch around this original feature, using the pencil mainly in the already described flat method, making sure the darker areas are clearly translated. For example, my sketch shown in *Figure 4* started with the little telephone box. By comparison I was then able to establish all the main features by relating them to this rather carefully drawn first item. It is surprising how quickly such a sketch develops and in a manner which is directly connected with and helpful to the needs of the painting which is to follow.

Carry on with the sketch and quite intentionally work a little beyond what you might, at first sight, have planned as the edges of your picture, for it is not until now that the placing of the scene on the canvas can be a little more definite. The *proportions* of the rectangle (canvas, board or paper) on which you are to paint are now of paramount importance as a rectangle of similar proportions is placed around part of the sketch. This gives an accurately reduced version of how the painting will appear. Thus if you intend to paint to a size of 20in × 16in (50cm × 40cm), make quite sure that the sides of the pencilled rectangle are in a ratio of 5:4; if your picture size is to be 16in × 12in (40cm × 30cm) the sketch must be confined within a border whose sides are in the ratio of 4:3, and so on.

Naturally the first attempt does not always produce the most satisfactory solution; that is the whole reason for the preliminary sketch. It may be necessary to move the pencilled border up or down, from one side to another, or even to change

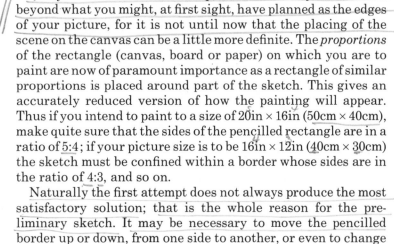

Figure 4 This example shows the advantage of extending the sketch. The problem of how to make it fit to given proportions can be considered later.

the composition from a horizontal one to one which is vertical. My example in *Figure 4* shows several possibilities, and the one chosen must be both pleasing and well within the scope of your talent. With growing experience, the drawing usually needs to extend only a little beyond the finally decided border, but the illustration serves to show both the possibilities and the soundness of the idea.

Besides helping a rapid grasp of the essentials of the composition, these quick preliminary sketches are extremely valuable in allowing the capture of fleeting moments when the scene is enlivened by unusual, often dramatic, effects of light. It is very difficult to keep these in mind during a prolonged session of painting, but the sketch will be of great help in providing an accurate record of some transitory impression. With a few colour notes in simple terms written around the edges, such a sketch allows the painting to be completed away from the scene so that a sudden shower need not mean that the work has to be abandoned. In fact many artists prefer to complete the final stages away from the subject, for they feel that it can be so dominant that it kills any attempt to make personal artistic interpretations.

Some artists carry a miniature water-colour box and put a few quick washes of colour over the sketch; this is quite a good idea, particularly if circumstances do not allow for a long session in one place. I remember a very happy holiday in Provence where several social calls to non-painting friends prevented any long session at an easel, but I still managed several of these 'quickies' and, because sufficient information had been gathered, they became quite successful paintings. One of the sketches is shown in *Colour Plate 1*. The division into quarters around the edges proves very useful when enlarging the sketch onto the canvas. The subsequent painting is shown on the dust-jacket. A few coloured soft pencils can also give some indication of the colouring, particularly if you have a reasonable number (about ten) and use them in the 'flat' manner already described. By increasing and decreasing the pressure quite subtle colouring can be registered.

In any given scene it is very seldom that everything composes itself *exactly* in the best manner and one often feels the need to rearrange things a little or to bring in some extra features to fill an otherwise too empty area. Sometimes a vertical accent, such as a tree or a post, is needed to overcome a very dominant horizontality; sometimes changes prevent boring repetition, such as a few irregular gaps in an over-long hedge. Often the composition might be improved by giving the scene a mental squeeze to prevent a gap looking far too wide. Improvements can often be effected by the simplification of detail, particularly in the middle-distance areas and it may well be wise to remove any very dominant far distant objects altogether. All such changes are permissible and even to be encouraged. However, a word of warning – never make changes for their own sake. They

should be made only for good reasons and should not be too numerous. If too many changes are needed it is fairly safe to say that the original choice of subject is at fault.

The closing of a gap presents few problems for the background usually remains unchanged, so that the objects which are moved will look very much the same in their new as in their old position. Where many artists go wrong is to shift some feature and expect it to look right against an entirely different setting. It never does, and the golden rule is to try to take its background along with it. Do not re-arrange, therefore, unless it is truly beneficial; if you do, make quite sure the uprooted items are taken from surroundings which are very similar to those existing in the replacement area. This may all seem very obvious, but it seems to be a common pitfall.

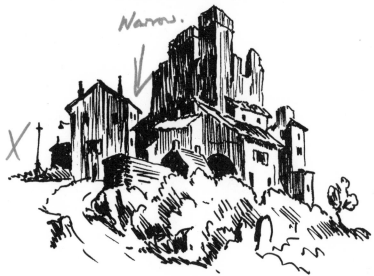

Figure 5 Occasionally the subject benefits from a minor rearrangement. In this case the slightly wider version (below) seemed an improvement.

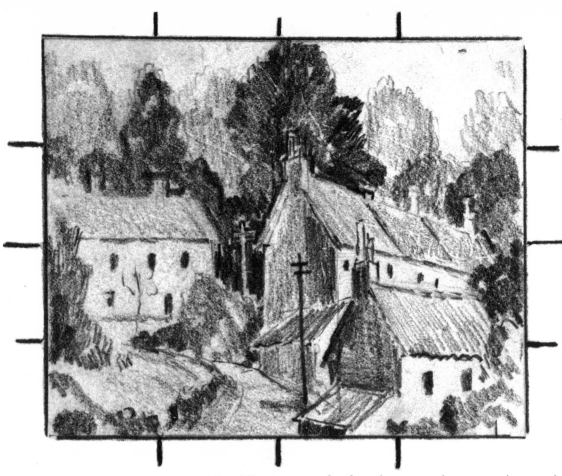

Figure 6 A sketch from my own book. Note the division marks which are extremely useful when the sketch needs enlarging.

All soldiers are taught that time spent in reconnaissance is never wasted, and the same is true for artists. The artist's aids to sound reconnaissance are his sketch-books; in one will be collected all manner of valuable information, and in the other those valuable pre-painting sketches. A good working-sketch, produced with a discerning eye and the subsequent painting very much in mind, will not only save time and prevent frustration; it will do more – it will surely improve your painting.

10

2 Materials

Enthusiasm and keenness are an important part of the magic of painting and I should hate, with a lot of rigid rules, to chill this eagerness. Any exciting small miracle of painting will have little chance of materializing, however, if working conditions are not appropriate. Conditions are very much governed by tools and materials and it is important to check that your equipment is in good order, is the most suitable to your needs and that you are using it and arranging it in the most efficient manner. The business of painting has enough problems of its own without adding to them or causing additional frustration or annoyance. It is extremely arduous to try to give all your attention to the niceties of the painting if you are fighting a constant battle with an unstable easel, or making continual breaks to find items which are hard to locate or difficult to unscrew. Painting should be a smooth and rhythmic, gentle and thoughtful process, and anything which disturbs or gives rise to agitation must surely prevent the finished work from being as good as it might be.

Supports

First, consider the material on which you intend to paint – the 'support', to give it its technical term. It matters little whether it is canvas, canvas-board, prepared cardboard, oil-painting paper or some specially devised surface of your own making, provided it is suitably prepared to resist absorption of the oil in the paint. Whatever is used, it is important that it should have some texture or 'tooth' which will readily take the paint from the brush. Such texture is a matter of personal choice, but it should not be so rough that one has almost to fight it to push the paint into the hollows. (That is why I so much dislike the very rough and mechanical grain of the reverse side of hardboard, which is suitable only when working rather large and with extremely heavy layers of paint.) Neither should the surface be so smooth and slippery that a brush becomes more efficient at taking off the first application than at putting on another. Personally I like the prepared canvas-type boards and the grained painting

papers which are now readily obtainable with a variety of textures, both of which allow one to begin painting immediately.

The canvas-type boards can be obtained in a variety of sizes, whilst the specially prepared oil-painting paper can be purchased either as separate sheets measuring about 20in × 30in (50cm × 75cm) or as stiff-backed pads in all the usual sizes, each pad containing about twenty sheets. If you use paper and later wish to frame the work, it can easily be mounted on cardboard by using a PVA-type paste, but as a precaution against warping, it is wise to stick a sheet of a cheap paper on the reverse side; the slight shrinkage of the two sheets of paper will be similar enough to allow the cardboard between them to remain completely flat. Alternatively you can get a framemaker to mount it.

Many artists maintain tradition by continuing to work on canvas; this is understandable because its surface is very sympathetic whilst its slight drum-like resilience, when it is strained across the stretchers which surround it, makes it responsive to even the gentlest touch. Artists' canvas, the best of which is made from pure linen, comes already prepared for painting and is available on stretchers in various sizes. Alternatively the primed canvas can be bought from the roll and fixed to stretchers which can be purchased separately; but as this needs special tools and considerable skill to avoid wrinkling, it may be best to buy canvas already stretched. In spite of the popularity of canvas, the more advanced techniques for the production of paper and boards (and also of adhesives and sealers) have made them equally acceptable and probably more durable than the much-loved canvas. They are also less prone to accidental damage or bruising.

Whatever support is used, be sure that it is quite rigid when placed on the easel. Loose paper or limp card should be firmly attached to a flat board; flapping corners or wobbling centres, with all the attendant smudges and accidents, can play havoc with one's powers of concentration.

The Easel

What about the easel? This is an essential piece of equipment for the oil painter, who needs both hands free – one to hold the palette, the other to wield the brush. To attempt to steady the painting with a hand already employed in holding the palette, whilst trying to put on paint with the other, can cause contortions guaranteed to retard any artistic progress. The painting should remain firm on the easel the whole time; firm enough to accept delicate strokes without any drumming and also firm enough to take bold and vigorous strokes without collapsing or 'walking'. Providing the easel will stand steady and secure and that there are efficient clamps, lugs or brackets to lock the support into position, it matters little what type of

easel is used. It can be a large studio model, a table-top type or, for outdoor work, a lightweight folding model. It might even be one of your own design. A word of warning: avoid those with too many clever gadgets. I have seen some hilarious Chaplinesque performances with artists endeavouring to sort out the far too numerous positions claimed for these over-ambitious implements. The golden rule is to have an easel which is both simple and rigid, for it will then allow you to proceed quickly with the serious and much more interesting business of painting.

A blustery day can be disastrous – I always carry a length of stout string with a hefty metal meat skewer tied on one end. The string is tied to the centre of the easel's tripod, and skewered firmly into the ground, making a good anchor which defies the strongest wind. If the ground is very hard I suspend a local stone, or my sketch-bag, on the string. Many easels possess bolts with wing-nuts, and I have found it wise to burr the ends of these bolts with a few sharp taps from a hammer. With the bolt-threads damaged the wing-nuts cannot spin off and a lot of crawling and searching is avoided.

As it is best to work standing, make quite sure the easel is of a type that will extend to a comfortable working height. In general, standing or seated, the most agreeable position is to have the centre of the work breast-high. Should you have to work seated, make sure the stool used is about normal chair height; anything lower quickly becomes extremely uncomfortable. Avoid arm-rests as they impede movement and are liable to jog the elbow just when a rather careful stroke is being attempted. Once you are comfortably seated, the easel can be adjusted accordingly, but take care that you are not too close to the work; it seems a very common failing for the artist to sit so near the painting that it is impossible to focus so that the *whole* canvas can be viewed at a glance.

The Palette

Traditional palettes are made from mahogany or some similar close-grained wood and these are obtainable in a variety of shapes and sizes; for normal work the rectangular one with its greater area is probably most useful. As these wooden ones are rather expensive, perfectly good substitutes can be made from hardboard liberally wiped with linseed oil before use, or from a lightweight board laminated with a thin sheet of hard plastic. If a plastic one is used, make sure the colour is greyish and neutral, for it is extremely difficult to assess colours correctly on a very bright and brilliant ground. If it is not necessary for the palette to be hand-held (although I always prefer this myself), a sheet of stout glass works extremely well. Hold the palette so that most of the underside is supported by the forearm; holding it the other way round will result in a very tired and over-worked thumb.

13

The palette is an extremely important piece of equipment, so make sure it is large enough. I find a palette measuring 14in × 18in (36cm × 46cm) is a good size, for it has a long enough perimeter to allow the colours to be well spaced around the edge, with enough room in the centre for mixing colours. A palette which is too small is a sure way of impeding progress for it allows little room for making subtle alterations and variations of colour. The palette is where the artist does his thinking; it is where translations are made, compromises effected and ideas created. Restrict the space and, without realizing it, thought itself is restricted. A larger palette has the added advantage of needing fewer halts. And keep it clean. It may look very arty to have a paint-encrusted palette, but when work is in progress it is more distracting to be unable to tell the new soft colours from the old dry ones.

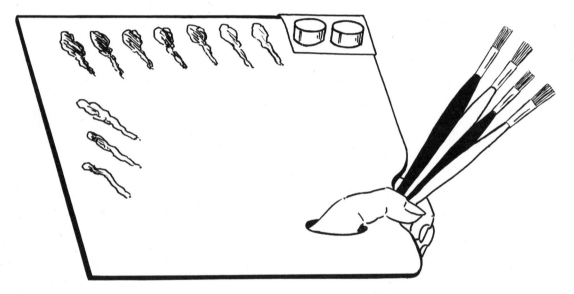

Figure 7 The best way to hold the palette: the weight is supported by the painter's forearm and his fingers are free to hold the brushes.

Brushes

For most types of oil painting hog-hair brushes are the firm favourite and it is wise to purchase the best that can be afforded. Very cheap brushes are a false economy for the hairs tend to splay out and lose their essential resilience. The shape of brush is a matter of personal choice, for you may prefer them round, filbert-shaped or flat. My own preference is for the flat type as I find it more versatile, giving a greater diversity of stroke and, in general, being better suited for the business in hand, namely getting the paint onto the canvas. These flat brushes come in two lengths of hair and again it is a question of taste as to whether those with long or short hair suit you best. Although I have some of each in my own collection, I do most of the more vigorous work with those with the longer hairs, for they are less inclined to become clogged with paint at the point where the hairs are inserted into the metal ferrule. It is difficult to advise

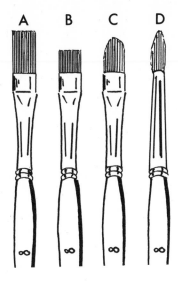

Figure 8 Hog-hair brushes,
No. 8
A–Flat, long bristle
B–Flat, short bristle
C–Filbert
D–Round

on the best sizes, for this largely depends on the proportions of the picture, but for work measuring about 20in × 16in (50cm × 40cm) one would need about eight or nine brushes varying in width from about three-eighths to three-quarters of an inch (8mm–12mm). One or two smaller ones can be included for the occasional small accent and it is also a good thing to have a small flat sable brush about a quarter of an inch wide (6mm), as this is useful when placing delicate touches over and into wet paint.

See that the brushes are in good condition. This may seem very elementary advice, but experience has taught me the need to repeat it. One cannot make sensitive and purposeful strokes with a brush that is worn out, splayed or even solid, and I have too often seen people try. A well-kept brush is a truly responsive and resilient instrument capable of interpreting a great variety of different movements and pressures. It naturally follows that the hand wielding it responds to such qualities and becomes increasingly controlled and capable of using it with sympathetic co-operation. Allow the brush to lose its essential qualities and the expressiveness of the hand is automatically suppressed. The brush is the direct physical link between you and the painting; if it is allowed to become hard, unyielding and unresponsive it can scarcely convey the poetry of your imaginative mental image. So keep your brushes in good condition by always cleaning them after use. A rag and a little turpentine will remove most of the paint. Warm water and plenty of soap will quickly return them to display-case condition.

Solvents and Varnishes

In oil painting, simplicity in the choice of materials will not only avoid confusion but will probably ensure lasting qualities. Spirits of turpentine and refined linseed oil are the two most necessary liquids for the oil painter. The turpentine is used mainly for thinning the paint during the first stages, when the canvas is covered quickly with a very thin coating of paint. It can also be useful for cleaning purposes, but if much of this is necessary then turpentine substitute (white spirit) will prove much more economical. The pure turpentine, added as a fifty-fifty mixture to linseed oil, will help to soften the tube colours if they are found to be a little too stiff for certain operations during the painting, though at the factory the artists' colourmen go to considerable trouble to have the consistency exactly right. The best plan is to thin the paint only for some particularly good reason such as painting over a 'wet' area, or to counteract a stiffness that prevents smooth and gentle manipulation. Try not to be over-liberal with the use of painting mediums – I usually find that a depth of about a quarter of an inch (6mm) in one of the little metal dippers that clip to the palette will last me the whole day.

Poppy oil, although not essential, is occasionally useful. It dries much more slowly than linseed oil; should you have to leave a painting for a couple of days and prefer working into wet paint rather than dry, then poppy oil would be the answer. It is slightly thinner than linseed oil and apart from slowing down the drying process is perfectly safe to use. On the other hand should you wish to speed up the drying process, a tube of an alkyd medium known as Gel is very useful. A blob of this can be placed on the palette and a tiny amount can then be included in each mixture, or, alternatively, it can be mixed with the white paint to the proportions of about one part Gel to five parts paint. Because the white is a notoriously slow dryer and because it is used in so many mixtures, the final painting will usually be touch-dry in twenty-four hours. A few drops of Copal varnish added to the fifty-fifty turpentine-oil mixture will have much the same effect and will also give a slight sheen to the work.

A confusing array of varnishes is still produced but a synthetic varnish is now available which is very clear and hard and to my mind much less temperamental than many of the old favourites such as Dammar, Mastic and Copal. It is usually labelled and listed merely as 'Picture Varnish' or 'Clear Picture Varnish' and has no preliminary adjective indicating its ingredient. If you like your finished work to have a shine, remember that a final hard varnish should not be applied until at least six months after completion to allow the more thickly painted areas to dry thoroughly. Any earlier attempt will seal the surface before the paint is dry and this can cause cracks to appear. When varnishing, choose a warm room, dust the painting carefully and wipe it over gently with a rag slightly moistened with white spirit. When it is dry, apply the varnish with a broad brush, keeping the canvas as flat as possible but occasionally tilting it against the light to ensure the whole surface is evenly covered.

If you prefer your work to have a slight sheen rather than a high gloss, a wax polish is extremely effective. Most paint manufacturers produce one, looking like a pale furniture polish. To apply, clean the painting in the usual way, apply the polish with one rag and, very much like polishing furniture, buff it up with another – preferably a piece of silk. It gives a very pleasant finish without any of the awkward reflecting properties that can be so disturbing if the work has a high degree of glossy shine.

Retouching varnish, as its name implies, was originally made for applying to a dry area of a painting, giving it the 'touch' of wet paint. This allowed for corrections to be made which appear to blend into the previously painted areas without looking hard and stark. Because retouching varnish will eventually fade away and because it does not afford a completely airtight seal, it can also be used as a temporary varnish on paintings which are apparently dry but have only recently been finished, which is convenient when one wants to display or exhibit work.

Paint

Most artists' colourmen produce at least two grades of oil-paints. Those of the very highest quality are usually listed as 'artists' quality' and have a high degree of permanence and contain the very best and most carefully selected pigments. Extreme care and precision is maintained throughout their manufacture and the degree of permanence of each colour is indicated either by an alphabetical sequence of initials or by a series of asterisks. The price of similar sized tubes varies according to the nature and expense of the ingredients – a tube of a simple earth colour such as Yellow Ochre is probably about one-third the price of any of the Cadmium colours. At the very top end of the scale, a tube of Vermilion is approximately seven times the price of the humble Yellow Ochre. If permanence is important for the work in hand or if expense is no problem, artists' quality is worth using.

The second grade is often referred to as 'students' quality', but usually carries a brand-name or trade-name to separate it from the top-grade 'artists'' range. In appearance and handling these are no different from the more expensive range and are extensively and effectively used by both amateur and professional artists. They are usually – on a swings-and-roundabouts principle – sold at a fixed price per tube, but to maintain this uniformity, certain of the more rare and expensive pigments have been replaced by reliable modern substitutes. Again the degree of permanence is indicated on each tube. Colours from both ranges will intermix, making a wide variation of choice, and in my own box there is quite an interesting mixture.

The size of tube to choose depends entirely on your output. If you are a busy person the No.14 studio tube (37ml) is the most economical; but for average activity the No.8 tube (21ml) will probably be the best buy, leaving the rather small No.3 tube (8ml) for the colours that you know you only use occasionally or rather sparingly. As white is used in far greater proportions than any other colour, a No.20 (56ml) or a No.40 (122ml) tube is the most economical purchase.

A final word on materials: whenever you are working and particularly if you are out of doors, set up camp, so to speak, and ensure that all the necessary equipment is immediately to hand so that any item can be reached with the minimum of walking, stooping, searching or stopping. It is most disturbing when inspiration is soaring, to realize that necessary items are awkwardly placed or cannot be found. Without being ridiculously fastidious, try to be well organized; it will give your talent a much better chance to succeed.

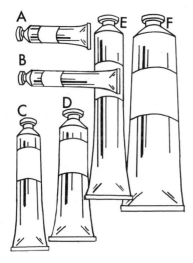

Figure 9 Capacity of tubes (shown ⅓ actual size)

A–No. 2, 2.5ml D–No. 14, 37ml
B–No. 3, 8ml E–No. 20, 56ml
C–No. 8, 21ml F–No. 40, 122ml

3 Painting
The Importance of the
Early Stages

Let us assume that you have made your sketch of some attractive scene; you have put up your easel and are all ready to start painting. Making sure your sketch has the very helpful quarter-divisions around the edges, pin it or stick it on the easel as close as possible to the canvas or painting-board. The idea is that you should, all in one glance, be able to see not only the subject, but also the sketch and the support. So check too that your canvas is not obstructing the subject. It is all too easy to discover oneself constantly peering round the canvas to get a better view, and I find it a good plan to place the easel a little to one side, so that by giving the scene a very slightly sideways glance, an uninterrupted view is obtained. This problem of blotting out the view does not arise when making the sketch, for the pad is usually held at elbow-level. It is worth remembering that painting has much in common with a smooth and regular circular tour. The route is from the scene to the mind – from the mind to the palette – from the palette to the brush – from the brush to the canvas. This 'tour' will probably be repeated countless times during the course of the painting, and it is extremely disturbing if there are hundreds of false stops to impede smooth progress. The aim is to prevent the eye from having to jog about too much.

Now for the painting. With a little blue paint, well diluted with turpentine to make it very weak, put in the quarter-divisions, for they will, with the aid of the sketch, help you with the enlarging. Some prefer to extend the quarter-marks to make a grid, although I myself find this a little disturbing. Then, again with the weak blue paint, make an outline sketch of the main masses of the subject. If preferred these basic outlines can be made with charcoal, which would later need to be fixed, but I prefer to recommend working with a brush as it encourages a familiarity with its feel and touch. Never do the outline drawing in pencil for later, when the paint is applied, the graphite in the pencil strokes becomes diluted and results in rather nasty grey patches which are difficult to control. Proceed with the drawing, looking at both the preliminary pencil sketch and the actual scene to ensure that the various masses are in the right places. Make no attempt at detail; at this stage one is simply

concentrating on the general structure of the scene, making sure it looks right on the larger area of the canvas. Sometimes one is forced to make changes, for quite often, even if the enlargement is very accurate, there are areas which, although acceptable in the small sketch, look much too bare, large and empty when the scene is magnified. A turpentine-soaked rag over a firm finger will quickly wipe out any wrong lines so that such corrections can be effected. My own enlargement drawing is shown in *Figure 10.*

The next step is the underpainting, shown in *Colour Plate 2a,* and its importance cannot be too highly stressed, for it is now that the interpretation into terms of colour starts. Much of the

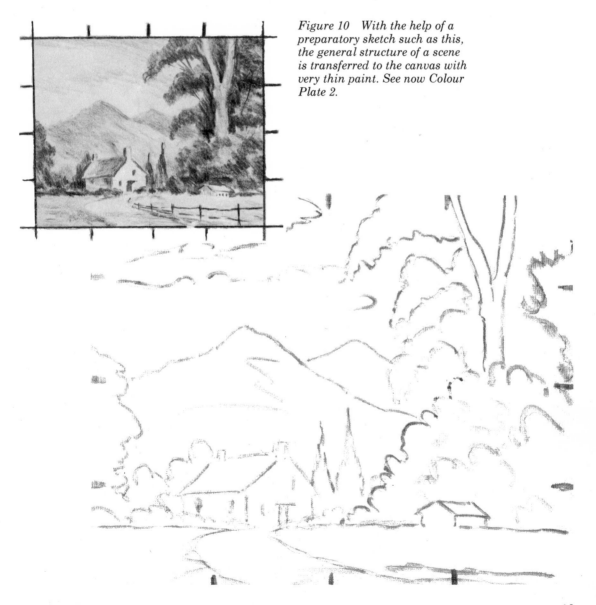

Figure 10 With the help of a preparatory sketch such as this, the general structure of a scene is transferred to the canvas with very thin paint. See now Colour Plate 2.

19

success of the finished painting is dependent on the reasoned completion of this stage of the work. Notice that there is no attempt to render detail. The large tree is just a green mass and the fence and the figure have not even been included. This stage of the painting is really a question of staining the canvas with very thin paint of approximately the right tones and colours. By covering the whole of the board or canvas, the various masses are established in very broad terms and the result gives an extremely good idea of what the final picture will look like.

Now to be a little more explicit. Your colours are carefully arranged around the palette and you have a dipper containing a little turpentine. With a fairly large brush (say a No.8), merely with mixtures of paint and a little turpentine, you are going to travel quite rapidly over the picture area, almost as if painting with water-colour. In fact the analogy with water-colour is quite a good one for no white paint is used. Any lighter areas are suggested by allowing the paint to be sufficiently thin and transparent for the white (or light-coloured) canvas to show through. This is not as difficult as it may sound, for so little paint or turpentine is used that, should you find something has been made too dark, it can readily be corrected by wiping gently with a rag until it becomes sufficiently light. Care must be taken not to be too liberal with the turpentine, otherwise the all-important darks will be unobtainable because the mixture is too fluid. I must repeat, however, that no white paint is used during this stage of the work. It is now I think that all tutors meet with resistance. An undeniably light colour is needed and yet the use of white paint is prohibited. On the face of it such a prohibition seems unreasonable, so that little piece of good advice is quietly ignored ... and the painting goes wrong. Another popular objection: why not go into thick colour straight away, because perhaps such a mixture can never be made again? This is about as reasonable as a driver refusing to change into top gear for fear of never getting into a lower one again. The artist must always have the courage and the ability to establish and temporarily 'lose' a passage, knowing that he can always recapture it.

White paint is not used during these early stages because it is a very slow-drying colour, and our objective at this time is rapidly to cover the board with the merest staining of colour which will dry quickly and not be lifted or smudged by subsequent applications. Mixtures using white, when applied in these early stages, tend to creep into other areas, making it more and more difficult to establish the right tone. Furthermore, it is not at all easy, once the thicker white paint has been introduced, to make changes and corrections. Colours which include white are very difficult to lift out, and trying to add to them or mix into them on the actual painting is one of the surest ways of producing muddy and sullied colours. The whole point of this initial exercise is to cover the canvas, endeavouring to get as near as possible to the right colours and the correct tones.

So resist all temptations and complete the underpainting without the use of white, as illustrated in *Colour Plate 2a*.

Although the scene is now stated in very broad and general terms it should, if viewed from a distance of ten feet or so, look reasonably accurate. If viewed from only five feet it should have the effect of looking at the scene through frosted glass. Although this part can be completed fairly quickly and although you need only this somewhat ghost-like look, still take great care, for it is now that the spirit of the scene is captured and this very largely dictates how to proceed with the later stages. A further point in favour of a well-established and informative underpainting is that if the weather stops work, the painting can be completed in the studio.

To correct a common fallacy: it is often said that oils are a fairly easy medium *because they can always be corrected*. This, like all sweeping generalizations, is only a half-truth. Of course, as oils are an opaque pigment, one *can* overpaint thickly to blot out what is wrong, just as one *can* take a rag or a palette-knife and continually lift out any offending passages, but these are hardly things one should *want* to do. At the next stage, when the paint is becoming rather thick, such an attitude can be disastrous. Naturally, minor improvements and gentle corrections can be made as the work proceeds. This is the right attitude: to build up gradually. A slap-happy approach – that of piling paint on recklessly without much thought because 'even if it's wrong one can always correct' – is deplorable. The work must progress with care, thought and knowledge, and any corrections should be minor ones, made at once.

Having established the picture by the placing of darks, lights and all the intermittent tones, it is time to build up on this with thicker paint so that it becomes richer in quality and texture, making full use of the delightful creamy consistency of the oil colours. Oils if used thinly always look rather poor and lifeless; used more thickly the real effect of their qualities begins to show. A thin oil painting looks like a rather cheap piece of printing on a poor fabric, whereas thick painting, with its surface texture, has a greater luminosity and richness and can be likened to a luxurious tapestry. This next stage, with the colours applied much more liberally, is shown in *Colour Plate 2b*. Now is the time to use the white paint in the lighter mixtures, for with a fairly accurate underpainting we can far more readily assess the accuracy of the colour.

At this stage of the painting I am often asked which is the best place to start, the question perhaps arising from some confusion over the dictum that one should always establish the darks first. This is quite true, but I think the key word is *establish*. Before one starts to paint thickly one should know exactly where these all-important dark areas occur, for without them there is no contrast and certainly no form. But such dark areas have been carefully indicated in the underpainting and therefore they *have* been established and their significance appreciated. The

statement does not mean that *always* one must, without exception, paint the darker areas first. At this second stage, when the paint is first applied more thickly, it is almost invariably best to start from far to near, which may well mean painting a light colour first. Let me give a very simple example. Imagine a rather dark cart-wheel almost in silhouette against a very light green sunlit field. Once it has been *established* which is light and which is dark, it must surely be both easier and wiser to paint the field colour first. Naturally the paint will go a little over the edges of the wheel and after that the wheel itself, with all its spokes, hollows, knobs, and shadows, can be painted. This is obviously more practical than trying to paint a beautiful wheel and then having to fill in all the triangles between the spokes.

So in my example I painted the sky first, making quite sure, in spite of the movement within it, that the dome-like quality was maintained. The underpainting served as a good reference and changes were only made if they were seen as an improvement. What is immediately visible at this stage is the vast difference in quality between this thicker and quite opaque layer of paint and the rather thin, poor-looking underpainting. Whilst painting the sky I took care to include a few strokes where I considered the 'sky-holes' in the tree would be and I also made sure the sky colours went a little over the sky-line of the hills; thus when the hills were painted, the crests and ridges did not have such hard edges as to make them look razor sharp. This practice of painting slightly beyond a given area is a very good general hint, for a soft edge, particularly in landscape painting, nearly always looks more acceptable: the resulting slight merging of the colours of two adjacent masses gives a much better rendering of the effect of space, light and air. The hills came next and I first painted them all over in a middle tone of blue-grey with only slight variations to indicate the beginnings of volume, again painting slightly beyond the edges. Into this blue-grey area the subtle changes of colour were added, first mixed on the palette with some of the blue-grey included and then, with the gentlest of strokes, placed (and sometimes merged) into the existing colour. All the time this background was being assessed against the trees and other objects overlapping it.

I shall go into the question of colour mixing carefully at a later stage, but at this point it would be as well to mention how valuable are the subtle greyish areas to be found in every painting. There is a variety of ways in which a basic grey can be made, but one of the simplest is to use varying mixtures of Ultramarine/Burnt Umber/White. The blue and brown mixed together will give an extremely dark colour – almost black. By adding a little white one can see more clearly if the mixture veers towards a cool (blue) grey or a warm (brown) one. A little intelligent play on the palette, by changing, altering and lightening, will create a wonderful variety ranging from a dove-like grey to a quiet tint of mushroom. Into such mixtures can be

added other colours whose range, variety and delicacy still delight me.

Although I was itching to get on with the lovely dark tree and the cottage, I resisted the temptation as I felt that if I put in a broad indication of the field and the path I would have a better suggestion of the ground from which these objects grew. This was done, but very simply, allowing scope for a few extra niceties at a later stage. My attention then went to the trees and although these were now treated more carefully, they were painted with an eye very much on the generally rather dark tone of the whole mass; such areas that were slightly lighter were put in a little later. Much the same treatment was accorded to the cottage and the small hut.

Towards the end I went all round the painting once more, as shown in *Colour Plate 2c*, enriching any darks which might have got sullied and finishing any areas which may have been treated a little too casually. Next came essential improvements to such things as windows, twigs, roof-tops and, as part of this attention to detail, now came the moment to include the fence, the figure and the animals; as well as some general softening and tidying. These were put in quite thickly with a clean and constantly wiped brush and lastly, carefully, any crisp, pure highlights.

Provided the right start has been made, all usually goes reasonably well until the final stages: but then far too many artists get carried away when there is the chance to put in details. Such details as are included should help the picture and in no way become so fidgety and distracting as to destroy the general unity of the scene. Cast a critical eye at your broad preliminary sketch which probably conveyed the essential story in very simple terms; then look at your painting and decide carefully how much or how little detail really needs to be included. Another problem that arises at this time is that the brushes and the palette are getting dirty and out of control; should this happen, be quite resolute and stop. Clean the palette. Dip the brushes lightly in turpentine and give them a thorough wipe. It is best not to swirl them around; just dip, lift and wipe, and the turpentine stays clean. If the brushes are too dirty for this treatment, have one or two clean ones ready to be brought into action. It is essential now to keep everything, but most important the work, clean and brisk and sparkling.

I hope this chapter and the painting have helped to prove the point that the success of any painting is very much dependent upon sound preparation and a gradual building-up from and improvement upon the original ideas. To take lumps of oil paint and smack them straight on the canvas may well be wonderful for ridding oneself of all kinds of inhibitions, but if you are wanting to improve your painting ability such a method will only lead to frustration and disenchantment. Take care with the preparation and the early stages, even if it means a certain retracing of steps, and the subsequent work will surely be richer in both quality and discernment.

4 Towards a
Better Control

The occasional need to retrace steps is an important factor in the development of painting ability. Over-keenness often results in last things being done first, and I am convinced that many leisure-hour artists are obstructed from making real progress by a constant desire only to paint 'pictures'. They would be wise to take a leaf from the book of those whose talents find expression in the performing arts; the singers, musicians and dancers, who put in hours and hours of practice before ever attempting anything approaching a finished performance. Artists too need practice, and indeed those who are successful spend a great deal of time in sketching, drawing and practising various aspects of painting which might present problems at a later date. It is far wiser, and ultimately very much quicker, to indulge in some form of practice, thereby acquiring sufficient skill and dexterity for expression to flow freely from the brush in an almost subconscious manner. It is rather like driving; once we have learnt to control those blundering hands and feet properly, a stage is reached where we do all the right things almost without realizing it. With a few (dare we call them) exercises, the painter's hand will control the brush in much the same effortless manner.

This 'picture only' attitude is very understandable but should be overcome. For so many amateur artists, time is limited, yet there is a great urge to be creative and to produce something both pleasing and satisfying. Unfortunately during the course of the painting a problem often arises which they are not yet experienced enough to solve. This causes considerable frustration resulting in a very worried and overworked passage which visibly displays their hesitation and uncertainty. It stands out like a sore thumb.

The point I want to make is that a few practice pieces now and then will, in the long run, allow for advancement to be made much more rapidly. There is no need for these to be dull, uninteresting chores; quite often they can be small studies which incorporate some of the problems previously encountered. Others could be devised from what is contained in these pages; perhaps this encouragement might even inspire you to tackle things which previously you had fought shy of. What

better, during long winter evenings, than quietly to experiment with those aspects of painting which are your own particular failing?

For such exercises no attempt should be made at picture-making; it is merely a question of gaining the necessary experience for the hand automatically to obey the message that the brain has given it. Should it go quite wrong, no harm is done; no masterpiece is ruined; and if you work on the reasonably priced oil-painting paper, no vast expense is incurred. One merely gives a philosophical shrug and has another try – and nobody need ever see the failures!

Before any paint is put to any temptingly empty surface, let us first consider the all-important question of how the brush is held and used. I am quite unashamed in going back to this basic point, for I have noticed, even with experienced amateurs, how common is the inability to use the brush in a way that is both versatile and sensitive. Far too often good work is spoilt by heavy-handed dabs and smears when what was really needed was a series of well-defined and gentle brush strokes. Another common failing is a restriction to one particular grip the whole time. All too often the forefinger and thumb are very flat, straight and practically glued to the very tip of the brush. This grip almost locks the wrist and makes it impossible ever to hold the brush except at a right angle to the canvas.

This unpainterly angle, with its associated rigid wrist action, not only produces strokes which look uncomfortable and robot-like to make, it also renders almost impossible the introduction of any kind of brush drawing. This is particularly unfortunate, for it tends to widen the gap between drawing and painting when in truth every stroke of the brush is really another form of drawing. Granted, it may be drawing in mass rather than in line, but it is drawing nevertheless. It is far better to practise holding the brush in a variety of positions and with differing grips; it will soon be clear how many more things are possible. A very much looser version of the pen-grip already disparaged may occasionally be useful for the odd tiny stroke if the brush is held well along the handle. If a complete change is made, however, and the brush is held with the back of the fingers facing the canvas, there is immediately much more scope. The whole hand and arm are free right to the shoulder and you can utilize movement from fingers, wrist, elbow or shoulder, or any combination of these. The sketches reproduced in *Figure 11* give a clear idea of what is meant. The purpose of long handles is to prevent you from getting too close to the work and to enable you still to hold the brush somewhere near the point of balance – the fingers should be kept well away from the bristles.

Having got the feel of the brush, try painting a series of fine lines into wet paint. This is a sure test of delicacy of touch. Furthermore, it is a useful skill to have in stock, for when fine lines are needed they are often put in when the painting is dry with the result that they tend to become rather over-sharp and

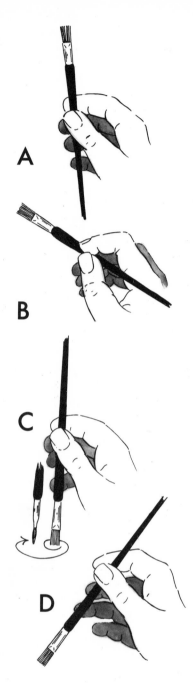

A

B

C

D

Figure 11 Endeavour to gain greater expression by being versatile in handling the brush.

diagrammatic. If a softer, gentler effect is required the technique of painting fine lines into wet paint must be mastered. A good idea is to take a small piece of painting paper and cover an area with a fairly thin but opaque layer of light-coloured paint. Then, using an ordinary flat hog-hair brush (say a No.6), pick up a dark colour which has been slightly thinned with a little medium (equal parts turpentine and linseed oil). Holding the brush bristles downwards, as shown in *Figure 11c*, turn it so that one corner just touches the previously painted area. If the painting surface has a slight backwards tilt, one can, by merely letting the weight of the brush do the work, make a gentle upward movement. A thin, even line should result, and you can see some of my own trial pieces in *Figure 12*. It is surprising how much can be done before the brush picks up the lighter colour. When it does, give the brush a good wipe and carry on with the practice.

A little experimenting will soon show that an extended third finger will serve to increase or decrease the pressure and all kinds of pleasing strokes are at your command. A series of delicate twigs will no longer look like a plumber's nightmare, nor will that section of fragile fencing look as rugged as a row of railway sleepers. Having explored the possibilities of the hog-hair brush repeat the process with a flat sable, for it may well suit your hand better, particularly if you need some very fine lines. For this job I do not recommend the small, pointed water-colour type brush, as I find, by reason of its very fine point, it runs out of colour rather too quickly. The oil paint, being thicker, also tends to collect at the point, causing an almost unavoidable blob. If the brush is stroked so that the hairs take on a flat shape (like a screwdriver) the results are very much better – in which case one might just as well start with a brush that was made to be flat. By all means try it, but I think you will agree.

Colour Plate 3 shows an on-the-spot painting made at Evercreech in Somerset at Easter time. I have included it as an example of how this fine-line technique can be put to good use. It also came in useful in the painting shown in *Colour Plate 2c*, for adding the twigs and the long fence.

Another very helpful piece of brush control is the mastery of gentle gradated areas. Unless one is working on something like a rather sharply defined pattern, the need for both soft edges and gently merging areas constantly arises. It is an effect much required in landscape painting where so often one area appears to fade off before the next one overlaps it. Skies, hills, mountains, meadows, slopes and sky-lines often need such treatment. It is also important in dealing with overlapping architectural masses, in portraiture, still-life work and in the successful handling of shadows. Its mastery is essential and for artists who tackle quite ambitious subjects without such control, the chances are that their painting will become laboured and lifeless and the lovely atmospheric qualities will finish up as a

Colour Plate 1 Water-colour washes can be floated over the pencil sketch to give added reference (see page 8).

*Colour Plate 2 A Scottish
homestead seen on a sunny
afternoon. The attraction here
was the bold pattern of the
features in the middle distance
which lent interest and mystery
to the atmosphere-laden
mountains. The background
was treated very simply, for any
overstatement of the distant
features would have spoilt this
effect (see Chapter 3).*

*a Once a preparatory sketch
has been done (Figure 10) the
general tones and colours are
broadly established with very
thin paint. No white is used at
this stage.*

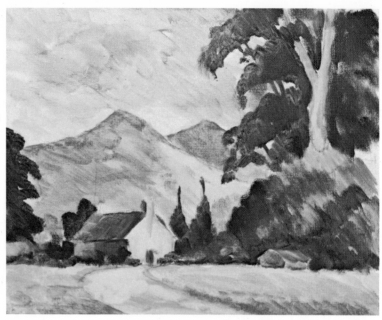

*b With thick paint (and
using white when necessary)
the painting is built up,
keeping the desired effect
constantly in mind; in general,
the work progresses from
background to foreground.*

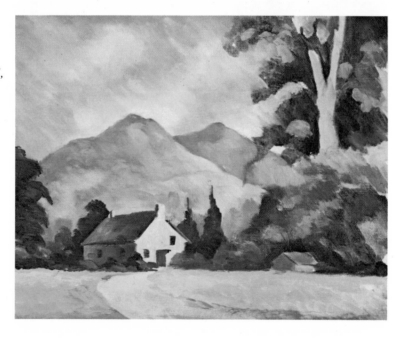

c *The final touches: minor alterations and subtle changes of colour are now made. Enhancing details are included but care is taken not to overstate these. Finally crisp highlights are added.*

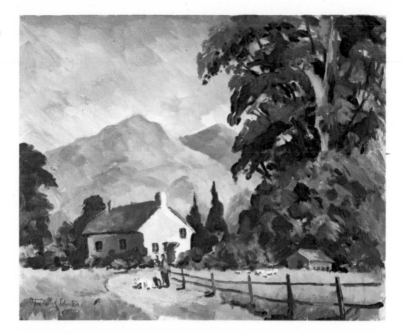

Colour Plate 3 Spring in Somerset. *An example of the effective use of painting fine lines while the canvas is still 'wet' (see page 26).*

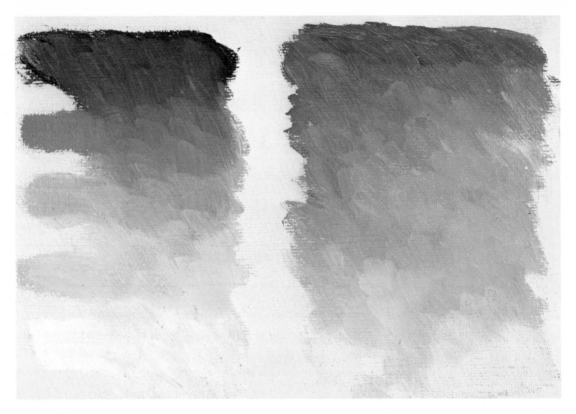

Colour Plate 4 Merging colours to achieve a fine gradation of tone is a most useful technique.

Colour Plate 5 The principle shown in Colour Plate 4 is here used to indicate volume and form linked through a change of colour (see page 44).

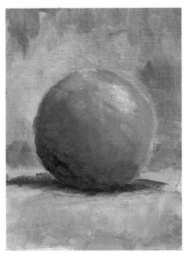 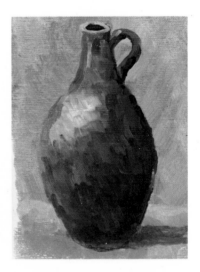

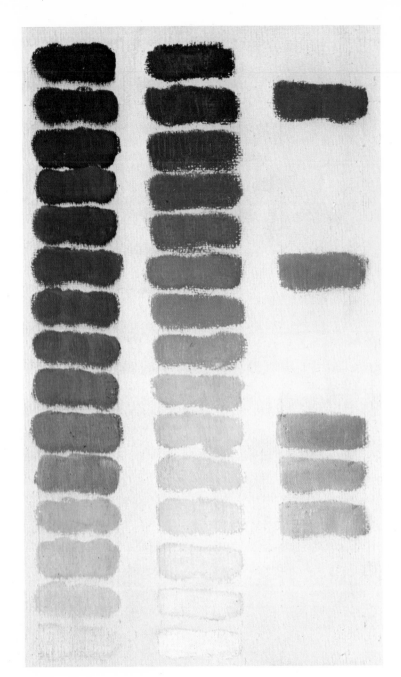

Colour Plate 6 Try making a tonal scale, which is more difficult than generally supposed. Then try to match some of the tones, working several feet away from the original.

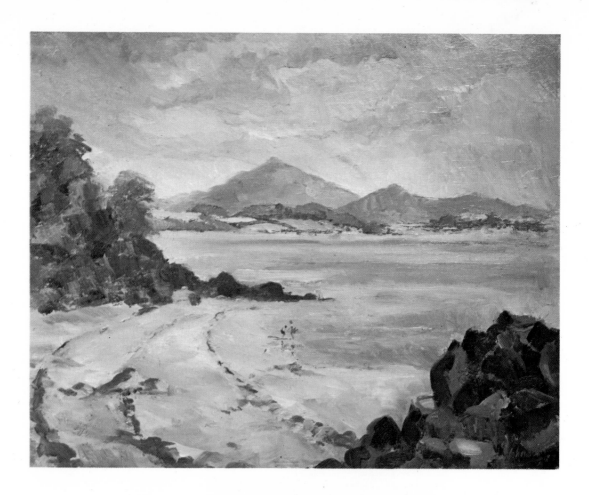

Colour Plate 7 Cardoness, Galloway. *An example of an overall need to merge and blend colours can be seen in the sky, the hills, the water and the sand.*

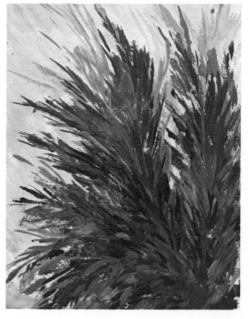

Colour Plate 8 *There are occasions, such as this, when a well practised flick can be much more effective than a stroke that is careful, definite and unevocative (see page 45).*

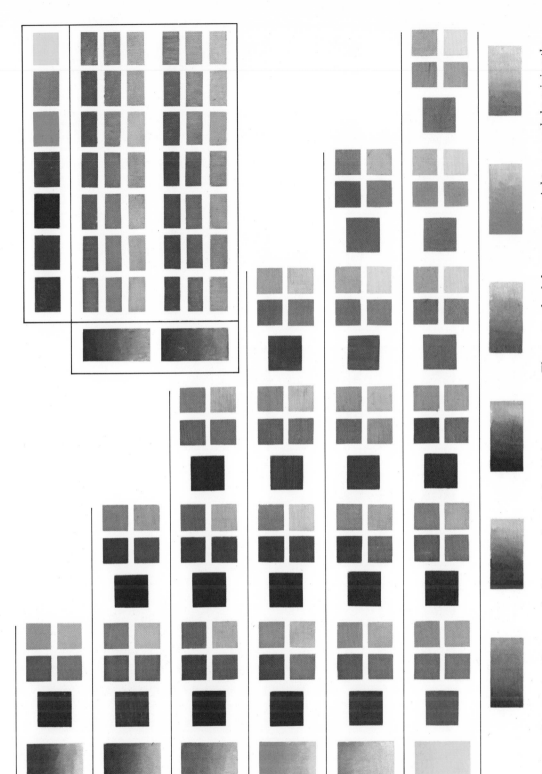

Colour Plate 9 A wide range of colours can be made by mixing a colour from the left-hand column with one from the bottom row. This chart offers only a few examples; many variations can be made according to the proportions used in each mixture.

The range of subtle greys at top right was made by mixing the very ordinary greys on the left with one of the colours from the top row (see page 50).

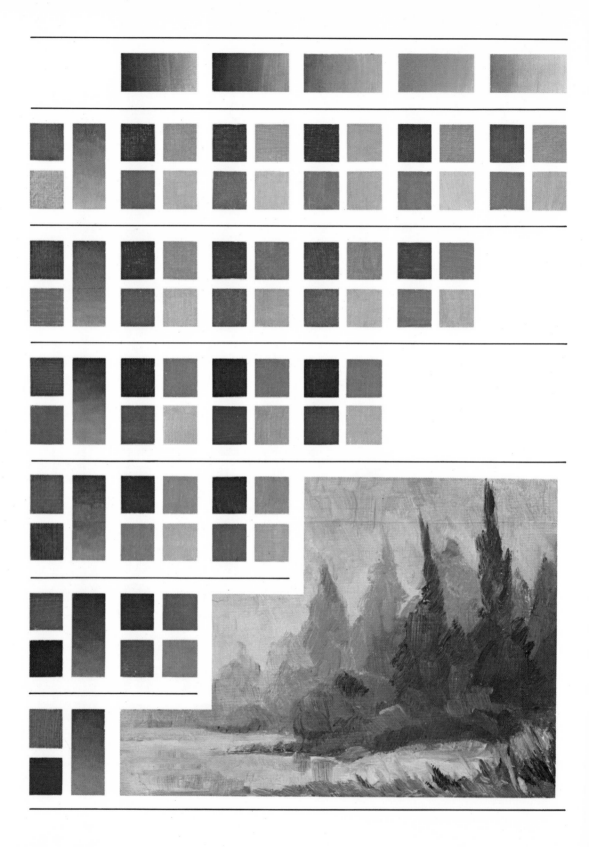

Colour Plate 10 (opposite) A vast number of different shades of green has been obtained by careful mixing. The two colours in the first (left-hand) column were mixed to produce the green shown in the second column. It was this colour from the second column which was in turn mixed with each of the colours in the top row.

White paint has been gradually included to show, in four stages, how the colour will appear when lightened.

This colour sketch was made very quickly from colours left on the palette after making the chart.

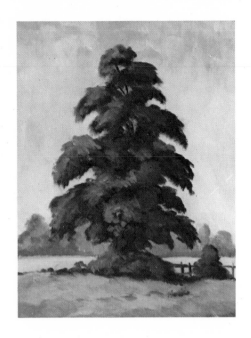

Colour Plate 11 (right) A broad and non-detailed interpretation is very sympathetic to the qualities of oil paint (see Figure 16, page 53).

Colour Plate 12 (below) West Lodge Park, Hertfordshire A very quick study which made full use of a wide variety of different greens (see page 52).

Colour Plate 13 Shadows are not simply a darker shade of the object on which they are cast (left); they contain an element of grey-blue purple which should be conveyed (right).

Colour Plate 14a
REFLECTIONS
A careful monochrome study of tones will reveal that, when reflected, very light objects appear a little darker whilst dark objects reflect somewhat lighter.

Colour Plate 14b
REFLECTIONS
*The slight tonal differences
between images and their
reflections must also be recorded
when working in colour.*

*Colour Plate 15 (right) If there
is already enough pattern in the
sky it is usually best to ignore
the clouds. But even empty skies
can be made interesting through
changes of tone and colour in
harmony with the scene (see
page 60).*

Colour Plate 16 (above) When the sky is empty, and when it occupies most of the picture, the lovely cloud patterns become most effective (see page 62).

Colour Plate 17a
DUOCHROME STUDIES
The only colours used for this street scene were Viridian Green and Alizarin Crimson.

Colour Plate 17b
DUOCHROME STUDIES
Again only two colours,
but this time Monestial Blue
and Burnt Sienna (see page 68).

Colour Plate 18 Turn with
the tide. *In this study the*
complete scene was painted
with a restricted palette of
only five colours. Cadmium
Yellow and Cadmium Red
were introduced only for a
few accents just before
completion (see page 69).

Colour Plate 19 THE PERSONAL TOUCH
A lively vibrancy is created by the use of small, tapestry-like brush-strokes.

Colour Plate 20 Gentle brush-strokes evoke a peaceful atmosphere.

Colour Plate 21 Vigorous and unaltered strokes bring about a free and 'carefully careless' effect.

Colour Plate 22 A personal style which owes much to the influences and methods of the three preceding paintings (see page 72).

Colour Plate 23 Back street, Lincoln. *This painting was made on a canvas previously prepared and well covered with pink paint. Varying amounts of the original colour were allowed to seep through as the painting progressed (see page 74).*

Colour Plate 24
THE WIPING-OUT METHOD
a *The whole area is covered with dark colours and the lighter areas are then wiped out with a rag.*

b *The intermediate tones are painted and slight adjustments are made to the darker areas.*

c *The light and very light areas are now painted and modifications are made to parts previously painted (see page 91–2).*

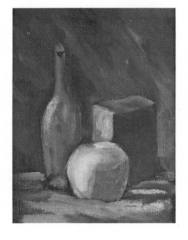

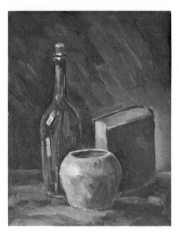

dull and rather spiritless grey. The exercise shown in *Colour Plate 4*, therefore, is strongly recommended. The left-hand panel shows a pure blue being gradually lightened. The method used is as follows: at the top of the paper paint a band of strong colour; almost immediately beneath it paint a band of slightly lighter tone, ready mixed on the palette. Then with a well-wiped brush gradually merge one tone into the other by making a series of separate strokes which can be in any direction and which can be left visible, provided they are not too disturbing or obtrusive. Resist the almost sure temptation to overwork and remember to wipe the brush constantly and firmly as this keeps the work clean and allows either the darks to be brushed into the lights or, if preferred, the lights into the darks. Now repeat the process with an even lighter band of colour, and so on down the paper.

The right-hand panel of *Colour Plate 4* shows exactly the same idea, but uses more than just one colour. This technique will be extremely useful when painting skies, or indeed any subject where both a change of tone and a change of colour will be required. Take particular care to mix each stage on the palette first and then to gradate the changes by strokes as deft and gentle as a caress. This merging effect certainly should not be sought by putting down colours that are near enough and mixing them all together on the painting. That is a bad habit, far too hit-and-miss, and to be avoided.

Figure 12 It is often more effective to paint thin lines into a 'wet' background (see Colour Plate 3).

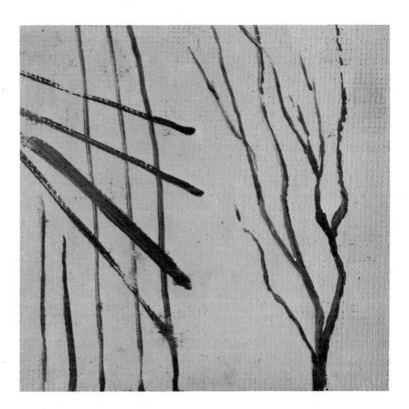

The two practice pieces shown in *Colour Plate 5* are really an extension of the earlier exercises and in both instances a little underpainting was completed first. The green ball makes use of just one colour, Viridian, varying it from full strength to a very light tone. The background and table were treated first using a variety of merged greyish-purples and greenish-yellows, working a little beyond the circumference of the ball. This avoided any hard edges. The ball, with its shadow, followed. The earthenware pot illustrated next to it not only makes use of the gradation from dark to light but also employs several colours and mixtures. These were combinations of Yellow Ochre, Burnt Sienna, Burnt Umber, Crimson and Ultramarine. In the first stages, after the background had been dealt with, the pot was painted with only Burnt Sienna and Burnt Umber. After careful brush-strokes had been made to give the pot a feeling of rotundity, the extra colours were applied and equally delicately brushed in. The temptation in such cases is to overwork, and this must be resisted. Great care was taken to wipe the brush constantly, otherwise too much unwanted colour would have been picked up from previous applications.

Closely related to the accurate merging of colours is the ability to mix the correct tone of any given colour. In any painting, if the greens, for example, are a little too light in one part and the reds are a little too dark in another, the balance between them and with all the other areas of the picture will be completely upset. The harmony and unity of the scene is destroyed and no amount of other technical expertise will ever put it right. The following valuable practice exercise, therefore, will eventually save considerable time and disappointment. Take a piece of ordinary oil-painting paper, about 15in × 10in (38cm × 25cm) and at the top put down a rectangle of any pure and fairly dark colour such as Burnt Umber or Ultramarine Blue. Use the colour direct from the palette, adding nothing to alter its purity and density. Then, taking a microscopic amount of Titanium White onto the brush, mix on the palette and apply this second mixture of colour immediately below the first. It should be very, very slightly lighter than the first application. Carry on in this manner as shown in *Colour Plate 6* and, with care and concentration, a good number of these lighter (or higher) tones should be managed before reaching a pure white. For guidance, if you can make twelve you have done well; fifteen is extremely good; twenty or more and you are a champion. Now try it with other colours, remembering of course that if you start with a naturally light colour, such as Yellow, you will not be able to create so many degrees to your scale. The meaning of tone values can now be understood much more readily: it is easier to appreciate how one colour can have a far larger amount of white mixed into it than another and yet register the same degree of lightness or darkness (tone).

Having made your tonal scale it is an extremely good plan to see if you can match one or two of the degrees on it from a

distance of several feet. Prop up the chart, retire into a corner, and try this idea of matching. If you paint right to the edge of an odd piece of paper you can easily place it alongside the original to see how you have fared. To the right of *Colour Plate 6* you can see my own attempt to match these tones complete with its slight imperfections – no cheating, I swear! This sort of thing is marvellous training and quite fun, and would admirably lend itself to the introduction of some friendly competition with kindred spirits.

As an example of how tonal changes and the gradual blending of colours can be utilized, I have included a painting of a Scottish scene which depicts the view from the coast in Galloway. (*Colour Plate 7*). This made considerable use of the techniques discussed so far in this chapter. How worrying and frustrating it would have been had these skills not been mastered before working on the painting.

Thin and spiky plants often halt progress, for they are difficult to suggest in paint. All too frequently they look as rigid and unbending as a row of sticks, when what was really wanted was a feeling that they would move and flutter in the slightest breeze. One way of achieving this lovely pliable effect is to paint one colour into another with what can only be described as a series of intelligent flicks. This is a difficult thing to master and needs many trials and experiments. Again, working on an already prepared but still wet background, pick up the desired colour on an ordinary flat hog-hair brush and, with a sideways action, make a series of quick upward strokes. The speed, and the lift at the end of each stroke will produce an area with an irregular series of growth-like points and spikes. Now try a darker colour – now a lighter one. With practice you will produce an effect somewhat similar to that shown in *Colour Plate 8*. Obviously this is not something to leave until the problem presents itself in a painting, because it is quite a difficult technique to master. Everyone has seen work marred by hardness and rigidity of an area which really should have been dancing and sparkling with suggested movement.

Many beautiful effects can be achieved during the later stages of a painting by applying one colour over another whilst both are wet. It is also much safer than painting over dry areas because the different speeds of drying often cause crazing and cracking. Such a technique demands a most sensitive touch, with the brush held so that the bristles lie almost flat on the canvas. I remember practising this technique by trying to paint the hairs on my forearm without exerting sufficient pressure to paint the skin. Perhaps not the best method of self-decoration, but at least in my case it helped me to obtain the control I was seeking. It was almost like painting on a canvas that answered back! *Figure 13a* shows the result of painting additional strokes on top of paint which is both wet and fairly thick. In this instance the background area was painted a very light colour. Then, with a well-loaded brush held almost flat to the canvas, a

Figure 13 It is quite possible to apply 'wet into wet' if the brush is wiped after each application. The technique is useful for occasional accents.

stroke was made using black paint. As you can see it is quite dense and clean and it was left untouched. As some of the light background paint transferred to the brush, it was firmly wiped in readiness for the next stroke – and so on. *Figure 13b* shows the same thing in reverse, namely placing white on to a black ground. This is a most useful method for placing last-minute accents into a painting, particularly final scintillating highlights.

I should like to finish this chapter with a plea. Discerning readers will agree with all that has been written, for their intelligence will appreciate the reasoning, and experience will no doubt provide confirmation. But understanding with one's intelligence is no substitute for the practical understanding that flows from the tip of the brush. If the points discussed in these pages coincide with some of your own weaknesses, please, in between the bouts of picture-making, find a little time for the 'five-finger work'. It will eventually pay extremely rich dividends.

5 In Command of Colour

Colour is a wonderful thing. It can create, enhance or even destroy a mood and with it the competent artist can achieve much more than the mere recording of the scene before him. Rather like the skilful stage-designer who, by the judicious use of coloured lights, can transform a scene without rearrangement, so can the artist create a variety of moods by the careful choice and mixing of different colours to present a picture with a very personal interpretation. It is well known, for example, that under normal daylight conditions colours of distant objects, such as an expanse of moorland or a range of hills, tend to lose much of their brilliance of colour and to absorb some of the blue-grey quality of the atmosphere. On the other hand the nearer objects have a greater purity of colour and in general become a little warmer. So far so good; but one artist may wish to record the scene with great accuracy of colour, whilst another may see it through an imaginary filter of a delicate pinkish-purple. Assuming that each of them was competent, it cannot really be declared that one work is right and the other wrong; all it is safe to say is that each is different and expresses something of the artist's individuality and personal style. And that is marvellous, for it would indeed be dreary if every painting of the same scene looked exactly alike.

Although colour can be the spice that gives work individuality, it is important to remember that it is also a dangerous ingredient which, unless used with controlled care, can completely ruin the flavour. Colour used unsympathetically without a knowledge of the many other elements which go to make a painting can very quickly lead to crudity. A struggling artist who cannot quite get the *form* of a tree correct may endeavour to throw one mass forward by putting in little strokes of neat Lemon Yellow. Had the tree possessed a few yellow blossoms, their inclusion would now be impossible because the blossom-colour has already been used in rendering some of the foliage. A simple example, but the lesson is there. Never be over-zealous in the use of brilliant colour at the expense of all else; the work soon acquires a very cheap and gaudy look. It is usually best to use a fairly small range, for this will bring a degree of harmony and unity to the work and will prevent the sudden intrusion of

some offensive or over-strident passage. Care must be taken, then, in the number of colours to be used, and thought must go into the reasons for their inclusion. It is always difficult to advise which range of colours is best, for nearly every professional artist I know naturally has very definite ideas on what colours to use, and what to avoid; without that there would be nothing delightfully personal about them or their work. They have reached the decision of what, for them, is a workable 'palette' only, however, after considerable trial and error when its possibilities were thoroughly explored. It is important to note that the chosen colours, whatever they might be, are in every instance capable of producing very strong darks when mixed together.

Tone is more important than colour for wonderfully expressive work can, for example, be produced in black and white only; providing the tonal qualities (the degree of lightness and darkness) are accurately suggested, the work will hold together most successfully. It therefore follows that any colour range should include enough pigments successfully to produce these low tones that are both rich in colour and deeply dark. The lighter areas are no real problem for these are quite easily made by the introduction of white paint. Of course bright colours too must also be included, but it is wise to avoid building up a vast range of what could loosely be called in-between colours. Strange and unusual colours are often purchased merely because Mary or Bill recommended them, without enough thought being given to whether or not such additions will be happy companions to the colours already in use.

The following palette is one which I strongly recommend, for it has been my basic one for a great many years; I only add to it or change it when special circumstance demands. It has proved to be a 'safe' range and has also been invaluable as an extremely good teaching palette.

Two yellows	—	Cadmium Yellow, Yellow Ochre
Two reds	—	Cadmium Red, Alizarin Crimson
One blue	—	French Ultramarine
One green	—	Viridian
One brown	—	Burnt Umber
One white	—	Titanium

The brace-mark linking my blue and green indicates that I consider it wise to think of the blue-green Viridian more as a blue to avoid it becoming too dominant when mixing the lovely greens of nature. Although they can be mixed well with the inclusion of some of this colour, Viridian very rarely appears in its neat form in any growing thing. I often point out that although it can be a most helpful colour, when mixed with

others, if left unmixed it can be used only for tarpaulins, park benches and tool-shed doors. To deny oneself the aid of this useful colour, however, when painting the landscape which is normally so predominantly green, savours of something very close to masochism.

The table below lists the colours used in the normal palette of six practising artists. It is interesting to note that although there are no two alike, each and every one of them has a basic foundation containing a strong version of a red, a yellow and a blue. After that come the additional colours they consider helpful in saving time and in maintaining an overall harmony in their work. I have repeated my own palette at the bottom for the sake of comparison.

A word or two about the whites may be helpful. Flake White is a very old favourite. It is a lead-based paint and extremely opaque. It is rather sticky in use and nearly always requires the help of a little medium to make it more manageable. As I tend to discourage the over-liberal use of a medium, which can so easily creep into everything, I find that Titanium White suits me better. This has a lovely creamy quality, is very opaque, has admirable covering qualities and is pleasant to use. Historically speaking Flake White, though it has a slight tendency to yellow with age, has been used for centuries whereas the Titanium has been with us for only forty years or so and is considered to be more resistant to discoloration. Both whites are extremely good, and the choice depends on which suits your hand and style best. Zinc White is much less opaque than the other two and is often utilized for scumbling (the modification of an already dry colour in a picture by dragging paint over it with a fairly dry

	Yellow	Red	Blue	Green	Brown/Black
Artist A	Cadmium Yellow Raw Sienna	Cadmium Red Alizarin Crimson	Cobalt Ultramarine	Viridian	Burnt Umber
Artist B	Lemon Yellow Raw Sienna	Alizarin Crimson	Prussian	—	Ivory Black
Artist C	Yellow Ochre	Alizarin Crimson Venetian Red	Monestial	Viridian	Burnt Umber
Artist D	Chrome Yellow Chrome Orange	Light Red Alizarin Crimson	Cerulean Monestial	—	—
Artist E	Chrome Yellow Yellow Ochre	Vermilion Alizarin Crimson	Prussian Cobalt	Viridian	Vandyke Brown Ivory Black
Artist F	Lemon Yellow Raw Sienna	Alizarin Crimson	Ultramarine	—	Burnt Sienna
Self	Cadmium Yellow Yellow Ochre	Cadmium Red Alizarin Crimson	Ultramarine	Viridian	Burnt Umber

Elm

Silver Birch

Sycamore

Yew

Figure 14 (above and opposite) Tree silhouettes.

brush). It is a technique not used a great deal in modern painting, and is the reverse of glazing, which is the placing of a darker transparent film of colour over one which is both dry and light.

An experiment in the mixing of colours using my own particular range is shown in *Colour Plate 9*. It is made to read like a cross-reference chart and it gives an indication of what happens when any two colours are mixed together. By taking a colour from the bottom row and mixing it in turn with each of the colours in the left-hand column a surprisingly wide range of colours can be created. Observe how very dark are some of the mixtures before any white is added – the importance of which has already been stressed – and how very subtle are the lightest tints of such mixtures. To get the most out of a chosen palette it is a good plan to make a similar chart, though it need not be quite as neat. It should be fairly large; about 20in × 15in (50cm × 38cm) is ideal. Many artists never get down to this job, but having once done so they are always surprised and delighted at the variations and changes produced. The beautifully restrained grey-purple that results from mixing Crimson and Viridian is a grand example – and look at all those quiet greens now at the command of the lovers of landscape. So far the experiment has shown the results of mixing only two colours at a time. The occasional inclusion of a third colour produces a palette of almost infinite scope and variations. I would not recommend the mixing of more than three colours; the resulting work may become muddy and uninteresting. It is important to experiment, so that mixtures will be remembered and to keep the work moving when inspiration is running hot. But freshness of colour is most important and oil paint which has been over-mixed can look very dull and lifeless.

Greys are well worth an independent mention. To the artist greys are never dreary and drab; because they have been influenced, however slightly, by the inclusion of colour, they become both subtle and pleasing. They help in the creation of happy harmonies and satisfying contrasts, particularly useful when trying to capture the essence of a restrained landscape or the variations present in the quiet colours of most interiors. The main chart has already shown that quite pleasing greyish colours can be made from only two colours, but to increase the range, the introduction of a third is often necessary. There are various ways of making a good basic grey, but a firm favourite of mine is a mixture of Burnt Umber and Ultramarine balanced either towards a cool or a warm colour by varying the proportions of each. It is surprising how many variations can be made and once the white paint is put in, such modifications are more readily apparent. If extra colours are then introduced a wonderful collection of pleasingly neutral greys is immediately at your command.

The chart at the top of *Colour Plate 9* shows how some of these greys are made. The top row shows my normal range of colours,

Oak

Poplar

Walnut

Cedar

whilst on the extreme left is shown first a blue-grey and, immediately beneath it, a brown-grey. The two rows of mixtures show the effect of the introduction into the grey of a little of one of the colours from the top row. The two rows of greys, although very similar, are certainly not identical. Such a range gives control despite the trick effects of wind, weather and atmosphere. The gentle inclusion of colour into grey will help with time-worn timber, the distant valley or the old stone bridge and gone are the days of dull army-blanket grey.

The many greens of nature often cause consternation. The predominance of so many variations of the one family of colour is always a problem, and I have even known artists to spend time hunting around an area to find another subject merely because they were unwilling to accept the challenge of too much foliage. But these green mixtures have got to be mastered, for they are everywhere and to avoid them is really deliberately to restrict progress. It is better by far to explore the possibilities of your own range of colours. In *Colour Plate 10* my seven basic colours were used to see how many variations of green could be obtained.

Viridian was used as a base and this, as shown in the second column, was mixed with a little of every other colour in turn. From these second-column mixtures an additional colour was made by the introduction, in turn, of one from the top row. Although quite a wide range has been achieved, it is only a small indication of how great it could be, because the results are dependent on the proportions used to obtain the mixtures in the second column. By altering these proportions the complete number could be doubled or even trebled ... and if a different green is used to start with, we could even double that! With such expertise almost any challenge presented by the dominant verdant nature of the landscape can be accepted.

Such mastery of the handling of the multitudes of greens leads to some general observations about the painting of trees and foliage. Each year I see many hundreds of paintings of the beautiful trees which grace our environment. Unfortunately far too many of these paintings are not only lacking in their range of colour, but also fail to appreciate a true understanding of the qualities and possibilities of oils. As far as colour is concerned, by far the commonest fault is that the essential difference is missed between grass-green and what could, very loosely, be described as a tree-green. Too much grass-colour in the tree and, no matter how hard the artist works, the result always looks as if the contents of the mower-box had been thrown into the branches. It is essential to have a good general medium-dark colour for the tree which will usually be very much warmer and contain much less yellow than the green of the grass. From this very general colour, variations can easily be made to alter the tones within the tree.

On the question of handling the paint sympathetically, far too often a vast amount of unnecessary detail is attempted. Unless

51

one is working on a close-up study of a particular piece of foliage, such a method looks too spotty and tends to put the artist at variance with the buttery and viscous qualities of the paint. Oil paint is suited to a broad, mass-like treatment and the results are always much happier if the number of spots and dots is reduced to a minimum. The knowledge that the tree is composed of thousands of leaves seems to bully artists into thinking too much in terms of detail rather than in the more important general terms of shapes and areas. The following approach works well for me and for a number of artists I have taught. It is really a short pre-painting exercise in observation. First, the tree should be looked at as a silhouetted mass of solid tone, which immediately creates the feeling of solidity and brings the tree away from its background, thereby creating an impression of air and space (see *Figure 16a*). Shape, however, is not enough and the next thing to observe is the main large clusters of foliage which appear within the overall solid mass. These will define the growth and give the tree its character. The separation of these areas is shown in *Figure 16b*.

Having broken the large mass into smaller patches, the next thing to observe is that each of these clumps receives a certain amount of light and shade and each has the power to cast its own shadow. A simple version of this is shown in *Figure 16c*; visualized without the hard diagrammatic outlines, it is getting very close to the appearance which should be sought for when painting in oils. It is broad in its conception and yet the fundamental qualities of growth and volume have been retained. Such observations are better preparation for painting something similar in treatment to the example shown in *Colour Plate 11*, because they have led away from the dangerous temptation of being over-influenced by detail. Naturally, I am not suggesting this is the only right way to paint a tree. To do so would be both foolhardy and incorrect. But if the scene is accepted with an eye trained to unity rather than incidentals, a much broader and freer painting is bound to result. Such a treatment also gives the artist greater scope for personal and imaginative development of his talent.

Colour Plate 12 shows a painting which, although completed very rapidly, made good use of many variations of green and was painted in a very free and loose manner. It was done during a painting excursion with members of my local society and the total time spent on it could not have been more than a couple of hours. It was a most enjoyable day, in the company of fellow-artists, and I was happy to indulge in what could easily be termed a valuable exercise. The small figures were put in to help in giving scale to the massive trees; something I will deal with later. But with or without the figures such exercises are of enormous help.

Figure 16
HOW TO LOOK AT TREES

a Observe first just the shape
and general silhouette.
b Within the silhouette look
next for the shape of the main
masses of foliage.
c Notice how each mass has its
own effects of light and shade
and casts its own shadows. We
are now ready to start painting
(Colour Plate 11).

*Figure 17 The radiating and
twisting nature of branches is
captured first by their shape
and, secondly, by the differing
patterns of light and shade.*

53

6 Atmospheric Effects

The effects that atmosphere has on subjects to be painted are far greater than is normally supposed. Anyone who has tackled landscape painting is soon aware of these effects, but all too often problems posed by some particular object are so demanding of attention as to exclude an appreciation that it must have the correct relationship to other passages which may be nearer or much further away. For this reason when I am painting, for example, a distant belt of trees which are undeniably dark against the sky, I always look for something nearby, which is also dark, to serve as a comparison. Branches, twigs, telegraph poles, chimneys, fences and bushes serve this purpose admirably. By moving one's head or sidestepping one can often make the nearer object appear to overlap the distant trees and it is immediately clear that they are not nearly as dark as was previously supposed, and the fading-off effect is all the more apparent. If nothing is conveniently placed, a black-handled brush or pencil can be held up to create this comparison.

This phenomenon must be thoroughly understood if there is to be any real progress. Of the hundreds of paintings which I am asked to comment upon each year, I would estimate that about half of them would have been greatly improved by an understanding of these qualities of recession, or aerial perspective, as it is sometimes called. The atmosphere puts a veil of 'mist' between ourselves and the things we see. The further away an object is, the greater the amount of 'mist' which our eyes have to penetrate. This makes distant objects very much more vague and quiet in tone than those which are near to us. The nearest things have more pure colours and well-defined highlights and shadows. As we look further away, the atmosphere creates the effect of a gradual merging of lights and darks, until the far distance appears almost as one general tone, the difference between light and dark areas very subtle indeed.

Atmosphere also has its effect on colours and it is well to remember that on nearby objects the colours are rich and usually a little warmer. As distance increases the colours also tend to merge until, in the far distance, they have become very much fainter and almost invariably have a content of blue-grey. Distant hills which we know to be green look decidedly blue when seen from far away.

This knowledge must be borne firmly in mind in order to make those gentle alterations and variations which give a work its pleasing individuality. A canvas is absolutely flat, yet the impression must be created that we could almost walk into it. Anything we can do to overcome this flatness and to help the feeling for receding areas, must be advantageous. If the whole background were painted to look fifty yards further away than it really is, the general effect might well be delightful and little harm would be done; reverse the process, however, and the picture will probably be ruined, because the distant objects will be trying to jump in front of those nearby.

Alternatively, paintings often need a livening-up of certain accents, particularly in the later stages. It may want the density of a little dark patch increasing to give more contrast and emphasis to an adjacent light area or the inclusion of a sparkling highlight to improve scintillation. Such things are important and often necessary, but care must be taken that the unifying quality of the atmosphere is not destroyed. A firm grasp of the effects of the veils of atmosphere will prevent these all-important extra touches from running out of control and destroying the essential impression of depth, space and distance.

For those who find the understanding of these atmospheric effects a little difficult to appreciate I have shown them in diagram form in *Figure 18*. On the left is shown a tonal sketch of a simple landscape study with some very conveniently arranged recessional planes. As the day was a little misty, there were no distinct highlights and the softening effect of the atmosphere was thereby enhanced. There are very few details and even the distant tower is merely a suggestion. What is so important is that each clump of trees recedes in succession, one behind another. Not always will nature present a subject which illustrates the point so clearly, but misty days and early mornings are good occasions for such examples which serve to prove the theory and confirm what happens. On the right of the study is a diagram which should make everything very clear.

Even when this phenomenon is clearly understood, mistakes still occur, often because insufficient care is taken in the mixing of the colours and the handling of brushes. If you watch a highly skilled artist at work it soon becomes apparent that far more time is spent on the mixing palette than in putting the brush to canvas. A mixture will be made and tried with a small stroke – then changes will be mixed with one or two variations in case they are needed – and only then will the paint be applied. The same care goes into the choice of brushes, for an experienced artist will avoid a continued use of the same brush for fear of producing a nasty meaningless colour. Even when a brush is dipped in turpentine and wiped very thoroughly, the original colour will creep down the bristles and have its effect on new mixtures. Make sure enough brushes are to hand for separate ones to be utilized for the lights, mediums and darks of each

colour. It will prevent the unintentional inclusion of something used previously. Failure to do so means the tones begin to go wrong and the atmospheric quality becomes disturbed. For general guidance, I usually consider it impossible to do good work with fewer than eight brushes. And a final hint is to have a good clean-up of the palette from time to time and to keep a couple of clean brushes in reserve for those all-important final touches.

Light has interesting effects, causing changes to occur according to the tone of the background behind or next to any given object. A very good example can be seen by studying light-coloured window glazing bars from inside the house. If you place yourself so that one of the bars has, at one end, a dark background (a tree) and at the other a light background (the sky), a most interesting change can be observed. When the bar is against the dark mass it will look decidedly light but when seen against a surround of light it will, probably to your surprise, appear to be quite dark. Reverse the background and you reverse the tone. This effect occurs also in the landscape, as when tree trunks are against dense foliage at their base and in silhouette against the sky higher up. Some examples are shown in *Figure 19*. Ridge tiles change their tone when one part of a roof is against the sky and another is backed by a very dark tree

Figure 18 Sketch and (opposite) related diagram showing the effects of recession.

or building. Where two masses of differing tones meet, the effect is particularly striking: where they appear to touch, the contrast is suddenly heightened and the light area is just a little lighter and the dark area a little darker. A good example of this can be seen at the left end of the cottage wall in *Colour Plate 2c*. These effects, and the general lighting and atmospheric conditions, must all be taken into account before painting commences and appreciation and understanding of them will allow for personal touches which, instead of disrupting the harmony of the scene, will do much to enhance it.

It is generally accepted that shadows and the patterns formed by them probably contribute more to a composition than the actual objects contained in it. The value of the shapes and patterns of shadows was considered when dealing with our preparatory sketches, but what of their colour and how best to paint them? To put on a solid, dense patch of colour is not the answer; it too often looks as though a strange-coloured carpet has been laid on the ground, or as if one wall of a house is indeed a different colour from the other. The problem is that one is using a paint which is opaque and yet trying to suggest with it something which in reality is transparent. This is where the water-colourists score for they can float transparent shadow colours over a passage already painted, whereas the painter in

	FOREGROUND	MIDDLE DISTANCE	BACKGROUND
Scale	Nearer objects appear to be larger	Similar objects appear to be smaller	Similar objects appear to become even smaller
Tone	Lightest lights and darkest darks	Lights not so light Darks not so dark	Lights and dark blend together
Colour	Colours are rich and warm	Colours begin to merge	Colours fainter with a blue-grey content

57

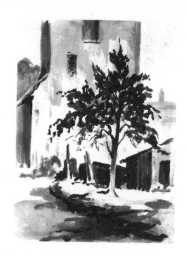

Figure 19 Sketches showing that the tone of any object will change according to the degree of light or dark in the immediate background. As the tone of the background changes, so (in reverse) does that of the object, often making it light at one end and dark at the other.

oils has a more difficult problem. A useful method when dealing with shadows is to paint in the dark shadow colour, and to brush into it a few variations of a darker version of sunlit areas. For instance, for a shadow across sunlit grass, the actual shadow colour could well be a mixture of Viridian/Burnt Umber/Ultramarine to give a deep green veering just a little towards a grey. The sunlit grass may well have been a mixture of Yellow/Viridian/White and this certainly cannot appear in the shadows, but one might successfully make quite a pure green with Viridian/Ochre and brush this intelligently into the previously painted shadow. This helps to give the shadow a much better quality of transparency.

But what of the colours of shadows in general? No one could give a hard and fast answer, for so much depends on the quality and brightness of the light. Shadows will, however, always contain a certain amount of cooler colour, which means the shadowed side of an object is not merely a darker version of the colour on the sunlit side; it is in fact a different colour and this can vary according to the warmth or otherwise of the light source. It is interesting to recall Cézanne's statement that he considered there was a little purple in every shadow. This may not be easy to observe in things which have a lot of blue in them, such as the dark shadows in tree foliage, but a study of the chart of greens in *Colour Plate 10* in order to choose some that suggest the correct shades of deep rich green, will show that, one way or the other, they do in fact contain varying degrees of purple. Objects that are of a warmer colour (yellows, oranges, reds and browns) have shadowed sides that display a coolish-purple content quite clearly. The illustration in *Colour Plate 13* explains this. On one cream-coloured box there is a brown shadow which looks quite wrong; on the other similar box the shadow is much more effective because of its cooler nature.

It is interesting to note that the warmer the light source, the cooler the shadow. This can be observed by engaging in a very simple experiment. On a piece of white paper, balance some slim

cylindrical object so that it stands up like a column (I normally use a fat pencil stub) and place it in such a position that a shadow is cast by the light from a normal electric bulb. If a match is struck and moved around, it is possible to make a second shadow, very close to the original one. What is interesting is that because the flame from the match is such a very warm light, more so than that from the bulb, the shadow it creates is very much cooler. It really is quite surprising – and it explains why some of the Impressionists who were painting in extremely sun-drenched areas were able, on occasions, to paint shadows that were almost a pure blue.

Reflections often present the artist with problems; a basic point to remember is that they appear to go straight down into the water, and do not seem to float upon the surface. The reflection has this feeling for verticality whereas the surface of the water, by its movement and recessional qualities, gives an immediate indication of its essential flatness. The reflection does not appear to become nearer to us towards the bottom of the picture: the water's surface does. For this reason it is very much easier if the reflections (though not shadows) are painted first, to create this essential vertical depth, and the water-surface is painted later, taking the strokes over and through them. In such a way the reflection goes down and the water looks level.

No one can give a hard and fast answer about the colour of water, for much depends on its depth, on the prevailing conditions and on the nature of the ground beneath it. Perhaps the most general observation possible is that in still water the lighter areas will usually be a little lower in tone than the sky, and it is only when there is a flurry of wind, causing thousands of scintillating highlights, that such areas will become very much lighter. In reflections the colours will be very similar to those contained in the object being mirrored, but subtle changes take place and these are well worth attention. Careful observation will show that the reflection from a light-coloured object is a little less light than the original; a dark-coloured object reflects an image not quite so dark. Middle tones remain fairly constant. An example of this is shown in *Colour Plate 24*. It can be proved by holding a white piece of card at right angles to a glass mirror. Although the household mirror gives a very good reflection, it becomes immediately apparent that the image is not quite as clean as the actual card. With something rather dark, the reflection is less dark. If this happens with a near-perfect mirror it must surely happen with water and it is our understanding and interpretation of these minor but gentle changes which help us to paint with greater sensitivity and to a higher standard.

In landscape painting the sky is the source of light and has a considerable influence in creating the mood of the picture. It is important, therefore, that it relates accurately to the rest of the painting and such unity and harmony can only be achieved by a

careful study of it. Always, the sky must relate and belong to the landscape which appears beneath it. By the same token the objects below must be at peace with the sky above. It is easy to become so thrilled with the nature of the objects in a composition that one fails to realise that the true attraction is how the atmosphere has, to some degree, absorbed them. Far too often paintings are seen where the sky has a colouring which suggests brilliant sunshine and yet beneath it appears a scene with a preponderance of alien areas made with mixtures containing large proportions of gun-metal grey. The sunlit areas and the crisp shadows are nowhere to be seen! Sometimes the situation is reversed and beneath a dull sky lies a highly sunlit scene. Had these artists developed an 'artist's eye' they would have retained the effect of unity and not allowed such a separation to occur. Sometimes, of course, dirty colours at the bottom of a painting are caused by a refusal to change brushes or to clean the palette occasionally – points which have already been stressed – but nearly always the faults result from a failure to look at the whole of the scene the whole of the time.

Such overall acceptance shows the importance of the effect of skies and clouds upon the landscape story and indeed on any subject for outdoor painting. The sky not only influences the general colouring – it creates the varying degrees of contrast between light and shade, sets the mood, and makes a general comment about the state of climatic conditions. In spite of this, the area in a painting devoted to the sky is often treated far too casually and a perfectly good painting is spoilt by incorrect colour or inadequate brushwork. A mass of fairly strong blue decorated with a few blobs of white to represent clouds is not a suitable setting for the scene, no matter how much skill is put into the rest of the work.

The following points may be helpful. The essential dome-like quality of the sky has already been discussed, and how it can be handled by the gradual merging of colours, making them lighter towards the horizon (see *Colour Plate 4*). But apart from such a recession of tone, what of the colouring? For a clear blue sky I find that Ultramarine, with its slightly purplish look, does not quite capture the feeling of warmth and infinity that is so apparent on such days. The introduction of a little Viridian gives a much more satisfactory colour, better suggesting the atmosphere than a mere Ultramarine/White mixture which is more an interior decorator's colour. However it is reached, a slightly greenish blue is the answer. Having obtained this colour and observed the recession of tone, attention should be given also to recession in colour, with the blues gradually changing to perhaps pale purple, pearly-greys or even a weak yellow ochre, as the sky recedes to the horizon or sky-line. *Colour Plate 15* illustrates such a characteristic. It is often a considerable help towards maintaining a harmony in the picture as a whole if some of the sky colour is introduced into other areas, and this is also shown in the illustration. Thus with

a little thought and individual application, even a cloudless sky can not only set the mood, but also be of considerable interest in itself.

When one is thinking of introducing clouds into the composition various other considerations immediately come to mind. First the position of the sky-line: avoid like the plague one which horizontally divides the canvas in half, for this immediately creates conflict and can easily give an impression of two separate paintings. If there is a very high sky-line, or if for other reasons much of the view of the sky is interrupted, it may be better to simplify the cloud formation considerably as a precaution against drawing attention away from the main centre of interest which, in such cases, must surely be in the landscape underneath. Nothing looks worse than a few clouds squeezed into a few inches of space left between the top of the frame and the tree-tops or chimney stacks. On the other hand, if the picture is to have a very low horizon or a considerable amount of uninterrupted sky it normally implies that the sky, and what is happening within it, is in its own right of significance to the picture. The inclusion of some sort of movement or cloud formation is now essential. Unfortunately, as clouds are transient things, they will not stay whilst we work at them and a little thought must be given to their arrangement (see *Figure 20*). Nearly always a somewhat uneven arrangement will look more natural and less static than one which is symmetrical and it is usually best to avoid a narrow, elongated, sausage shape which spreads itself right across the canvas. Particularly to be avoided is the inclusion of clouds which, most unfortunately, repeat the outlines of some dominant feature in the picture such as a tree, a house or a hill, and thereby create the effect that each object possesses its own personal heavenly halo. Such mistakes are so frequently made that it seems wise to repeat the warning.

As soon as clouds are introduced into a composition all manner of exciting and interesting possibilities are presented. Clouds have both mass and form, which are constantly changing as they are blown and driven by the wind. In rough weather, they appear either to be torn apart, or to build themselves up into towering masses, menacing in their power, size and strength of tone. Under the more normal conditions for outdoor painting, they become a little more regular both in their general shape, movement and behaviour. Isolated clouds will curve gently outwards at the top and their base will be flatter and tend to taper slightly, due to the action of the wind. They will also have exactly the same recessional qualities that are found in landscape; the nearer ones (those overhead) are larger and richer in colour, tone and contrast than those which are further away. It might help if the clouds were imagined as a series of boxes suspended in the sky and obviously subject to the laws of perspective. Each box would receive its light above, have a shaded base and the ability to cast a shadow on the earth, but

the whole group would be governed by the same rules as those governing a row of uniformly coloured cottages.

The painting of the sky is a continual process. One should not apply a general all-over sky area and attempt to place the clouds over it as an extra layer of paint, but should endeavour to work gradually over the whole. Even so, it is as well to remember that the cloudless areas retain much of the same essential qualities of recession as are maintained when no clouds are present. It will then be easier to keep a grasp of the necessary perspective when the clouds are gradually introduced, as can be seen in *Colour Plate 16*. As usual it is best to paint in the background colour a little beyond the edges of spaces allocated for clouds and this, if the touch is gentle, will prevent the edges from becoming too sharp. Note that the almost white clouds have a slightly clearer definition at the top than underneath; the definition is hardly ever really sharp but the top is certainly a little crisper than the base. Pure white is never quite true for clouds – it is too cold and should always have a tiny suggestion of the general atmospheric colouring which usually veers a little towards a slightly warmer colour. Some of the very light, clean, warm colours made when producing the colour chart will prove the most useful here, particularly those that include a tiny amount of yellow ochre. The base of clouds nearly always changes a little towards a greyish-purple and the knowledge gained when making the charts will once more be particularly useful. A very good hint when painting such clouds is to tackle the nearest one first, and due to the gentle merging that has to be done, the colour on the brush in use will become very slightly sullied. With care this slightly soiled colour will be very useful for making the correct tone for the clouds which are a little further back and, gradually, the recessional effect will be obtained.

Painting clouds with a clearly defined top and base is not nearly as difficult to me as trying to suggest a section of big windswept clouds which cover a large area of the canvas, such as the one shown in *Colour Plate 30*. The problems are greater because changes in colour are much less obvious and therefore the margin for error is even more restricted. The colours are all rather quiet; they need to be very carefully merged where they meet and change, and yet the essential quality of the whole scene being contained within a huge inverted bowl must still be retained. Over-zealousness when brushing the colours together easily results in the appearance of a nasty patch of mud-colour. Placing a colour which is only a little too fierce can also upset the whole balance. This is the occcasion to be in possession of two pieces of rag; one for frequently wiping the brush, and another ready to wipe out any offending touch before it has the chance of spreading its unwanted influence any further.

These problems constantly arise in the painting of skies, as is confirmed by the comments of a friend with whom I worked on a selection panel. There were three of us in all and our rather

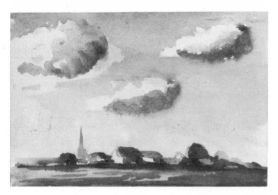
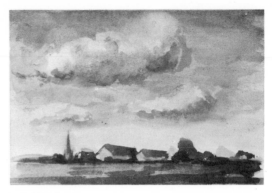

*Figure 20 Symmetrical clouds
will never look satisfactory so it is
wise to alter their size and
arrangement.*

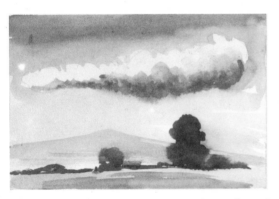
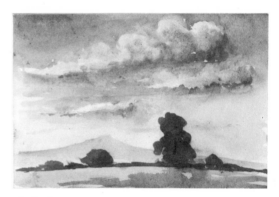

*A very long cloud rarely looks
successful unless it extends beyond
the edges of the picture. A good
plan is to include one or two extra
clouds to strengthen the
perspective.*

*This silhouette is so unlikely that
it immediately looks unreal: it is
therefore best avoided.*

unenviable task was, by selection, to reduce about 450 paintings to a level hundred. The organizers of the exhibition felt it would be a good idea to publish a letter explaining the main faults that prevented those works that were not hung from being selected. We felt this would be most helpful, and each sent in some general abbreviated notes which were collected, polished and finally published. I recently came across my friend's notes and, although they are still in their shortened form, their repetition confirms what has already been written. His notes read: 'The know-how for sky and cloud painting seemed to go little beyond using mixtures of a blue, a dull-grey and white – and too often the blue was artificial. Very little evidence that the majority of the painters know how to mix the light, weak hues for the shadow on clouds. Insufficient observation and practice …' Reports filtered back that our comments proved useful: I trust they will be of help once more.

The painting of skies offers a continual source of study and presents an endless variety of movement and colour. Although they are far from easy, they can, if carefully related to the light they transfer to the scene beneath, bring a considerable improvement to the quality of subsequent work. And they pay an additional bonus in bringing us so much pleasure.

7 The Value of a Limited Palette

All artists, if their tuition is sound, are encouraged during the early stages of their development to work in monochrome. This means using only one rather strong and dark colour with, for the oil painters, the addition of white for making the numerous necessary lighter mixtures. The reasons behind such teaching are very wise, for they encourage both a facility in handling the paint in a sympathetic manner, and a greater appreciation of the tonal qualities of the subject. Difficulties with colour mixing do not arise and, due to this reduction in problems, progress is gradual and orderly. Unfortunately, once colour has been taken up the poor monochrome is usually forgotten, being considered, rather unwisely, something for beginners only.

When artists have reached a fairly high level of competence, a return to making the occasional monochrome study can do much towards lifting their work away from the ordinary and towards the discovery of a more individual interpretation of the chosen subject. With a greater understanding of tone values they will be free to experiment with perhaps a broader approach, a more free style of brush-work or a crisper way of suggesting necessary accents. Problems with colour often preoccupy the artist, almost bullying him into giving up any attempt at making some courageous experiment in style or technique. The occasional monochrome study may well strike off such shackles. Furthermore, it will be a good test of appreciation of tone. It is not unusual to see work where emphasis has been sought by the introduction of some strange fierce patch of colour. For an outsider, with a fresh eye, the problem is immediately apparent; the areas surrounding this offensive patch were not of the right tone and the artist, instead of reading them correctly and making the necessary adjustments, attempted to save the day by including this alien area. With only a little experience in working in monochrome such a problem would not have arisen. Not only does the monochrome study give freedom in many respects, it also improves judgement. And it possesses all the elements of picture-making. It can depict recession, show the effect of light and shadow, and demonstrate the relationship of one shape to another. With such qualities and possibilities the humble single-colour study

Figure 21 This study not only shows how effective it can be to work in monochrome, but also demonstrates the differences between the art of the photographer and that of the artist.

In the photograph there is an accurate record of the scene with all the variations in tone and a considerable amount of detail.

In the painting, the general structure and tones are the same but there is the added quality of texture. Detail is kept to a minimum because to overstate it would be working against the nature of both tools and materials.

can be a beautiful work of art in its own right with no stigma of being a mere beginner's exercise. One word of warning: when making such studies be sure the colour used is one that is strong enough to register the very dark tones. Black, Burnt Umber and Payne's Grey are ideal. With lighter colours the all-important rich, dark tones are unobtainable.

Paintings in monochrome can be successful and exciting to produce; they also help to prove a most interesting fact about painting in general. A truly successful painting, one that displays something about the artist's originality and style, has an air of honesty and sincerity about it. There is no pretence; it looks like what it is – a painting. It does not, and should not, look like a photograph. One has only to look at a mound of oil paint, with its thick, buttery consistency, and to study a bristle brush, to realize that it would indeed be working against the nature and quality of such materials to try to produce the same results with them as with a lens and a piece of sensitized film. The photographer can be an artist too, but he also maintains his integrity by working within the expressive confines of his chosen materials. He would not, for example, set out to obtain the artificial inclusion of brushmarks. A painting should immediately be recognized for what it is – an original use of brushes and pigment. *Figure 21* emphasizes these essential differences between the art of the photographer and that of the painter. The place is the same in both pictures and is immediately recognizable, but each picture has its own praise-worthy qualities; each makes the best of the materials employed.

Another good idea is to restrict oneself to the use of only two colours, which gives rise to all manner of exciting possibilities. If the chosen scene would register well with a fairly warm look, why not try two different browns? Burnt Umber and Burnt Sienna would do very nicely, as one is a little more warm and gingery than the other. Or if a balance between cool and warm colours would suit the subject better, some very attractive work can be completed by employing a blue and a brown. First try the mixtures obtainable: pleasant surprises may result. For example, by experimenting with different blues it will be found that some of the deeper ones (Monestial, Prussian, etc.) when mixed with a light brown, result in a rather pleasing deep green which becomes beautiful as it is lightened. The idea of using colours that are not true to life should not be off-putting. Old sepia photographs, for example, in spite of the restriction of colour, had about them a very great quality and charm. Many of the old masters produced wonderful portrait studies by using grey paper, and black, white and red chalk – hardly flesh colours, but the results were perhaps even more beautiful than the subject because of the inspired control demanded by such limitations. The important thing to remember is that one can 'cheat' with the colouring but the tone (the registration of lights and darks) must be absolutely correct. This is borne out in the cinema when

a colour filter is placed across the film to indicate a flash-back in time. Everything looks right; the darks and lights are still in the right places and everything is still recognizable; only the colouring is changed – and often gives a most attractive effect. With this in mind, it might be worth trying something more ambitious, using Viridian and Alizarin Crimson, two rather strong colours, but capable when mixed of producing some very rich darks and some delightful purples and greys. Examples of such duochromes are shown in *Colour Plate 17*; the first using Alizarin Crimson and Viridian, and the second Burnt Sienna and Monestial Blue.

If the impression of something approaching a larger range of more natural colours is desired, a quite adequate variety can still be obtained by limiting the palette to only three, four or five colours. If choosing to work with three colours, instead of utilizing the three pure primaries (yellow, red and blue), try slight variations on them such as Yellow Ochre/Burnt Sienna/Payne's Grey. The range of mixtures available is quite surprising, but because of the limitations imposed, a certain unity and harmony is maintained throughout the work. The compromises that must be made when one is confined to a limited palette automatically induce greater care in rendering the correct tones, and this too is an aid to general concord.

Working along these lines soon sparks off all kinds of original ideas for personal interpretations. One is forced to simplify certain passages and even to create a harmony where little exists. Particularly in landscape work, a scene with obvious possibilities often possesses so many things which cry out to be noticed that one is left uncertain of how to state them in artistic terms. The over-busy scene is often far more expressive if certain passages are slightly understated by a careful simplification of both sharpness and colour, thereby leaving the greater emphasis for the more important areas. This is so when dealing with backgrounds which may be over-rich with a multitude of highly coloured spots and patches; if all these are accurately recorded, they may well draw attention away from the main feature of the painting. With a limited palette such wide variety of colour is just not possible and in consequence some kind of thoughtful simplification is encouraged. The results are usually both rich in harmony and distinctive in style. Even when working with a fuller range of colours such simplification can be most effective, as is seen in *Colour Plate 3* where the background frieze of trees and buildings has been considerably modified to give a greater emphasis to the trunks and branches that appear to cut through it.

Another good plan, when working with a normal full range of colours, is to keep back a couple of the very brightest (say a yellow and a bright red) and deny oneself the use of them until almost the last stages. By such action the painting can be seen better as a whole and one is in a much better position to judge just where any necessary bright and colourful accents should be

placed. Occasionally the odd little patch of luminous colour is exactly what is needed. There will also be the occasion when its inclusion would offend and it would be wise to ignore it. In either case the restraint will have helped. *Colour Plate 18* serves as an example, for it was only at the very last stage that Yellow and Cadmium Red were introduced to indicate the lamps, their reflections and the suggestion of rust on the hull of the large ship.

A few comments about painting from photographs: a sympathy for the scope of painters' materials and thoughtful interpretations of harmony and colour lead work far beyond the mere stating of the obvious which unfortunately is the case in much photographic work. If you are forced to work from photographic reference be sure to continue to convert it into artists' terms in the same way as if you were working from the actual scene. Never confuse art with careful copying – art is very much more. A famous artist put it clearly when he said that were he to produce something so 'real' that it could be mistaken for the actual scene, he would consider such work to be a miserable failure. He felt that his painting, if it was successful, should force onlookers to realize that they were looking at a brilliant example of how to use paint.

Of course a photograph can be useful as a source of reference and to give ideas, but it is of little use if it is merely copied. To do so is to confuse one type of picture-making with another. Photography is a useful addition to the sketch-book but it should never replace it, otherwise the eye no longer searches, the mind no longer creates and the hand is denied its essential practice. The secret lies in using the photograph merely as an aid which in itself really demands considerable experience. The wisest plan is to rely mainly on the sketch-book. Without specialized experience the photograph becomes too demanding in its claims and so the resulting painting is easily recognized as being a mere copy. That is yet another reason for the development of a personal technique and style; it lifts work away and above the level of being a mere catalogue of the obvious.

All through this chapter, I have recommended limiting the palette, on occasions to the use of one or two unusual colours. This does not mean that one should paint the trees red and the cows green simply out of perversity (although there may be occasions when this could look very exciting or perhaps charmingly naïve). The aim is to help advancement by the modification and simplification of certain aspects of painting. Reducing the number of colours normally used is an excellent method of sparking off such rethinking. Not only will the resulting studies themselves be satisfying, but a greater harmony and profundity will be evident when a wider-range palette is later brought into use.

8 Towards a More Personal Style

Art is always changing. Not only can one see the more obvious changes in style from one generation to the next, but careful study reveals that almost all great artists at some time made important changes in their outlook and method of working. Often the changes were major ones, stemming from a great dissatisfaction with existing standards; others were a little less obvious, more in the nature of a gradual evolution of personal interpretation, brought about by the interchange of ideas with friends and associates, or by the influence of refreshingly new ideas brought into an ever-shrinking world. Whatever the reasons, these artists, in spite of their brilliance, all reached a point where, if advancement was to be made, there had to be some change of direction. With all due humility and deference, what was true for them is also, in our small way, true for us. Having reached the stage of painting a very adequate tree, boat, barn or figure, the work, although quite competent, may well have little about it to lift it above or away from the hundreds of paintings completed in a very similar style.

Without proposing to discuss strange and deep philosophies, to explain a few additional methods and techniques should help to give a greater range of skill and facility with which to make individual interpretations. This may be the means of elevating your work on to a slightly higher plane and of lifting you out of a rut to a better sense of direction. There is usually no shortage of ideas; the frustration comes because the hand so often does not measure up to the intelligence and inspiration that seeks to guide it.

Consider the enormous significance of brush-strokes. Every artist would agree that when working in oils, the very long sweeping stroke is seldom effective and is far better saved for painting the kitchen door. A shorter stroke looks better, handles better and suits our materials better. Whatever the style of painting this seems to be generally accepted and although in a fairly conventional or representative painting these strokes can vary in size and occasionally be merged together, the work is ultimately simply a series of hundreds of separate strokes. Why not, then, give a slightly greater emphasis to the fact that so many separate applications are present

and necessary by letting them be more clearly visible? The resulting work would then have an appearance and a quality reminiscent of a mosaic or a richly woven tapestry. The scene shown in *Colour Plate 19* of a view of one of the bridges over the Montgomery Canal on the Welsh borders, makes use of such a method, for the separate patches of colour are quite clearly visible. This means that great care is taken on the palette to ensure that each mixture is exactly right with a minimum of brushing-together on the canvas (although there will be odd occasions when a little of this may be necessary). Make sure that you cover the whole of the work with paint; any little gaps which are left will eventually look quite dirty, although this can be overcome if the canvas is treated first with an additional application of good quality undercoat which is allowed to dry. The method follows in the steps of Cézanne who is reported to have taken five minutes over every brush-stroke! We need not be quite as fastidious as that, but the statement serves as a reminder that success depends largely on careful mixing and a controlled touch. In my example the strokes slope at a variety of angles, but there is no real objection to them all having the same direction, provided no difficulties are presented in maintaining correct shapes for the various masses. Indeed a uniform direction to the strokes can often bring a pleasing effect of unity to the work. If the method has not been tried before a diagonal stroke is easiest; for right-handers from top-right to bottom-left, with a reverse action for those who, like myself, paint mainly with the left hand.

Such a style and method does not appeal to everyone. The pattern-like qualities may not be in sympathy with what you consider are the softer qualities of the scene, and the slower progress of such a method might, in your opinion, rob it of its apparent spontaneity. In such a case it would be worth experimenting with a style which makes considerable use of gently working up to and into adjacent areas which are still 'wet', in a manner similar to that shown in *Colour Plate 20*. The result is very soft, gentle and restrained and full of a feeling for space and atmosphere. To help with this effect it is a good idea, before any painting is started, to cover the board or canvas with a very thin film of linseed oil. This helps the paint to 'slip' a little and thereby encourages the rather soft effect. As only a very small amount is needed, merely enough to make the surface shine, I usually apply it with a small pad of rag about the size of a walnut. Be careful, as too much oil will make it almost impossible for the paint to grip and the whole work then becomes a rather slippery mess. As in all other paintings, great care must be taken in establishing correct tonal values, and anything remotely like a really hard edge is to be most carefully avoided. This calls for a feather-like touch and a continued use of brushes which are carefully wiped, so that any hard line can be very gently softened by the merest touch. This can be seen throughout the reproduction, but is particularly obvious where

the trees meet the sky, along the top of the bridge and in the tall foreground grasses. There are parallels here with both Monet and Turner. No words or examples can give a complete answer applicable to everyone, but perhaps the general principle of painting in a slightly softer and less definite manner may set in motion ideas which ultimately will lead to a general improvement. Much of the attraction of the two methods so far explained stems from the very different manner in which the brush is handled and the paint applied.

Yet another style of working relies largely on a different handling of the brush and this might prove helpful if, after a quiet appraisal of your work, you felt it would benefit from a more bold and vigorous approach. The method is direct, vibrant and displays a controlled exuberance, and its success largely depends on a careful assessment of the tone and colour of adjacent masses in combination with a direct and lively application of the pigment. I have endeavoured to paint in this style in *Colour Plate 21* and it is very reminiscent of the quick sketches recommended in the first chapter. Although the inclusion of detail is kept to an absolute minimum, sufficient attention is paid to the 'drawing' to ensure that the essential qualities of form and structure are maintained. So although the brush is wielded with both speed and vigour, and although the whole thing looks very spontaneous, it needs rather careful thought and careful mixing before each 'attack' is made. I am reminded of the 'slow, slow, quick, quick, slow' jargon of teachers of ballroom dancing. After the normal underpainting has been completed, the double-slow period is the careful early assessment of the subject and the consideration of how it should be expressed in a painterly manner, and secondly, the careful and gentle mixing of the colours, allowing plenty of time for thought and modification. The 'quick-quick' period is for making the brush-strokes which, although they may vary from a single touch to a controlled wriggle, are put in deftly with speed and vigour. Resist all temptation to tidy them up a little, for this would almost certainly mean losing the essential freedom which is the very essence of this method of working. The final 'slow' period is for criticism and consideration of what has just been done. If it looks good, leave it alone and repeat the process elsewhere; if it is wrong, wipe it out (do not try to paint over it) and have another go. At the very end a few deft touches may be needed, but once again restraint must be exercised to maintain unity; spotty details would spoil the work. This is a difficult method, for although the whole thing looks loose and fresh, it requires a good understanding of drawing to hold such nebulous qualities together. It is a method which needs both practice and courage, but it may prove helpful on your road to advancement.

The last illustration of the same scene, *Colour Plate 22*, shows the original painting from which the preceding three interpretations were made. It was painted on the spot and I have included it because I feel it shows that in varying degrees some

of the qualities of the other three versions have subconsciously crept into it. Every artist is influenced, directly or indirectly, by the work of others and this influence combines with the characteristics of his own hand and his individual outlook to produce a unique, personal style. With a little practice at some of the methods which have been explained, you may evolve a style that suits you . . . at least for a time, for progress is a constant thing and the finishing-post of today becomes the starting-point of tomorrow. Even a minor breakthrough, however, is a cause for celebration.

No mention has yet been made of working on a tinted ground, which is often very helpful for it avoids the rather fierce glare of a pure white board or canvas and thereby makes it a little easier to assess the correct tonal value of the colours in the all-important underpainting. There are two methods of doing the tinting. One is to take a little colour, usually a Yellow Ochre or one of the warm, rich browns and first, with just a little medium, to brush it on the centre of the board. Then, with a rag moistened with a little medium, it is rubbed into the surface until it presents a fairly light uniform covering. White paint is not used; should the tinting be desired a little lighter, greater pressure is exerted when rubbing in the colour. The painting then proceeds in the normal manner and because there are no pure white areas to worry about, progress is often much smoother. A note of warning, however, must be sounded. Quite often a series of tiny patches of the original tinting colour show through where subsequent applications of thick colour have left gaps; and these little patches of warm colour, scattered about, as they are, all over the painting often have a very pleasing effect by complementing and breaking up the larger areas. Unfortunately, as the original tint is so weak and diluted, it may fade off in a very short time to look rather dirty, and all the earlier sparkling quality disappears. So, if you find the tinted ground helpful and if you like the look of the little coloured areas peeping through, make sure that as the painting proceeds these are painted with a richer and less transparent colour. They will then always remain clean and bright.

The other method is to tint the board with an opaque layer of paint and this time, plenty of white will be required if the colour is to be fairly light. This is allowed to dry before the real painting commences and it is a good idea to have a few boards of various colours prepared beforehand. For practice purposes one can use a good quality white undercoat with a little tube colour added, but for more serious work I prefer to thin down a little Titanium White before adding the desired colour. The advantage of having the ground colour opaque is that should small patches now show through they will be quite permanent. Indeed we can take the idea further, for if the background colour is chosen carefully, larger areas can be left to show – rather in the manner of the pastelists, who allow the colour of the paper to do a large amount of the work. The similarity goes further:

gentle brush-strokes placed over the coloured ground can be so controlled to paint only the high spots of the textured surface, giving a scintillating effect not unlike that obtained when working with pastels. But the importance lies in the permanence of the result. The lustre-like qualities do not fade as they are liable to if the ground colour is extremely thin and transparent.

The quick colour sketch shown in *Colour Plate 23* gives an idea of the method put to use. I saw this little back street in a late afternoon light and fortunately had a small board with me which had previously been tinted a very light peach-pink. This helped the glowing effect that I wanted to capture and was allowed to show in many areas. Indeed, in parts of the wall and the road, no other colours have been added. Naturally the choice of ground-colour very much depends on the nature of the scene and the ideas you have in mind, and no doubt ideas would come by referring to some of the subtle greys that were created when producing the colour chart. In this case the glowing quality of the late afternoon light was considerably helped by having such a clean and pure colour on which to work. The sketch is now about four years old and has still retained its colour.

Colour Plate 25 Bonfire night.
*In this painting with its large
proportion of dark and middle
tones, wiping out proved
invaluable (see page 93).*

Colour Plate 26 Palette-knife painting – practice piece (see page 95).

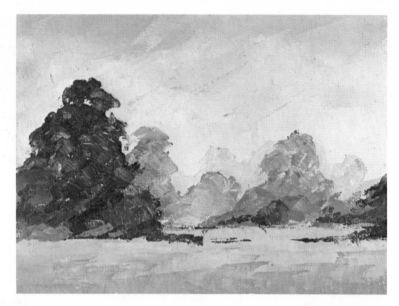

Colour Plate 27 Castle in Sussex. *Palette-knife painting made from on-the-spot sketches.*

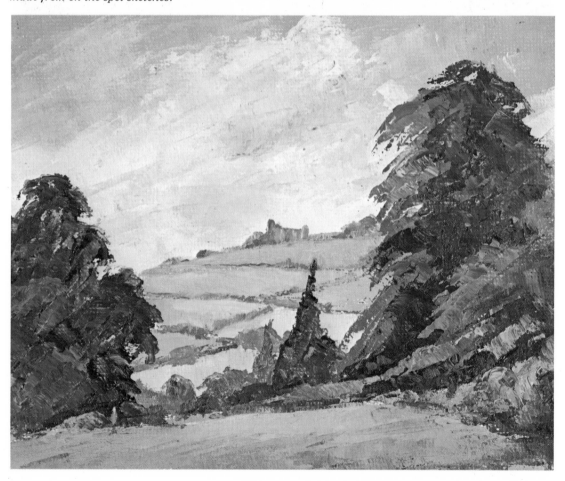

*Colour Plate 28 This study of
a storage barn required a clear
understanding of the principles
of perspective.*

Colour Plate 29 South Bailey, Durham. *Another exercise in perspective.*

Colour Plate 30 This scene of a church near Canterbury shows how a broad interpretation of figures can often be more effective and harmonious than a tiny photographic portrait.

Colour Plate 31 Painting practice. *From sketch-book studies make broad sketches with paint. Start by making them about four inches (10cm) high and then reduce them to about one and a half inches (3½cm). Work into a wet background.*

Colour Plate 32
THREE FOREGROUNDS
a The conventional approach
for which the immediate
foreground, although
recognizable, is kept a little out
of focus.

*b Here the objects in the
foreground are painted with
clarity and contrast, and the
background is considerably
simplified.*

*c In this large foreground
every stroke shows an
understanding of the perspective
of size, tone and colour.*

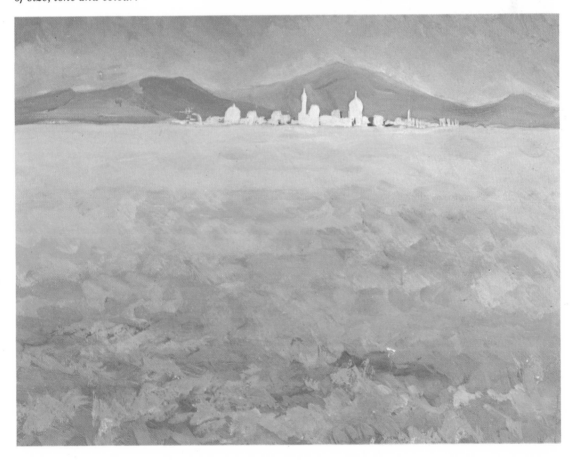

Colour Plate 33 STILL LIFE
a The group was arranged
and drawn to check on the
quality of the composition.
Then, with thin paint (and no
white), the various masses were
thinly applied. Care was taken
with the dark colours for these
established the form.

b With thick paint (using
white when necessary) the whole
painting was then gone over,
very broadly. Attention was
given to mass rather than
detail.

*c The finishing touches
included making minor
alterations to both shape and
colour. Suggestions of necessary
detail were included as were
any crisp highlights.*

Colour Plate 34 Fishermen's gear. *An example of an interesting subject found by accident when seeking shelter from a cold wind.*

Colour Plate 35 Such a subject could well be listed as an 'outdoor still life'. Similar groups are attractive and usually found where work is (or has been) in progress.

Colour Plate 36 An example of how important leaves are in helping to project blooms. The canvas also shows how different is the interpretation when working in oils instead of line and wash (see Colour Plate 37).

Colour Plate 37 A subject which lends itself readily to the crispness and transparency of a line-and-wash technique.

Colour Plate 38 (opposite). A little careful arrangement can prevent the pot from being too dominant.

Colour Plate 39 White
clematis.
*a The subject is drawn and
'stained' with colour made very
thin with turpentine. No white
is used at this stage.*

*b The background areas are
covered with thicker paint. A
rag is used to re-establish any
light areas. White is now added
for lighter colours.*

c The background is improved,
nearer objects established and
necessary detail included. Fine
lines and highlights make the
final touches.

Colour Plate 40 Flower painters occasionally need a few extra colours. In this study of anemones the introduction of a purple and an additional red made things considerably easier.

Colour Plate 41 Plant subjects need not be limited to formal arrangements or highly coloured blooms. This subject was painted from beneath an improvized shelter on a rainy afternoon.

9 Further Techniques

There are many instances when the artist is confronted with a subject whose appeal owes much to the fact that almost the whole scene is low in key (rather dark) with subtle and restrained changes of tone and colour. Only a few passages are brightly lit and the subject is one of soft, unifying qualities and delicate variations, with little that is bright, sharp or definite. Paintings which successfully capture this effect make use of a mysterious understatement which is strangely satisfying. Such subjects are often found in densely wooded areas; in interiors (barns, boat-sheds, churches, etc.); in landscapes at night, or even by day, when, through some unusual atmospheric effect, the lighting is restricted in some manner. Under certain conditions the same effect can be observed in many still-life groups.

Consider the problems of those who paint in oils when confronted by a subject which is mainly dark with only a few light accents. The normal approach of working on a white or very light canvas is fraught with difficulties, for it is extremely difficult to assess the tonal correctness of a dark colour when it is surrounded by a large, glaringly light area. A less direct and definite method of working might well be the answer and for this reason I recommend the making of occasional practice pieces in what is often called the 'wiping-out method'. This means starting the painting by wiping out the lighter areas from a previously applied dark or middle-toned background. These lighter masses can then be painted in their desired colour. The method of working is outlined below.

The preparatory stage entails covering the whole of the picture area with a suitable colour or colours for the background, which should be weakened with a little medium and applied thinly. Use no white paint at this stage. As it is merely for practice there is no need for specially prepared surfaces; a piece of good quality oil-painting paper works extremely well. Do not indulge in any drawing at this stage but merely cover the paper with a fairly thick and patchy application of dark colours. They should approximate the general effect of the background when seen through half-closed eyes.

Having established the background, make use of a rag-covered forefinger, dipped into turpentine to wipe out, boldly and firmly, the few very light areas. Remember to change the rag round from time to time as it soon becomes dirty. Do not worry unduly about making mistakes as these can quickly be brushed out ready for another try. This is drawing by erasing, and it is quite surprising how quickly the subject begins to reveal itself. Having wiped out the lightest areas, next indicate those parts that are at varying stages between the very light and the very dark, the intermediate tones. These too can be wiped out, but for such passages the rag needs to be wielded with a somewhat lighter touch. In my example (*Colour Plate 24a*), the background was painted liberally with variations and mixtures of Monestial Blue, Burnt Umber and Burnt Sienna. (The careful reader will notice I have used two colours additional to my normal range, but I considered the low tones of the subject justified one or two substitutions.) No white was used at this stage. The lightest areas were then wiped out: the left-hand sides of the bottle, the book and the jar, with one or two flashes on the table.

Then came the turn of the 'intermediate': in the area behind the book, on the remainder of the jar and the bottle. At this stage the composition should suddenly become recognizable (see *Colour Plate 24b*). These should now be painted – fairly thickly – and their correct rendering will necessitate the introduction of white into some of the mixtures. Notice that the lightest areas have still not been painted and in such patches the almost bare paper can still be seen. During this stage it will probably be necessary to make slight alterations in the darker areas. The illustration shows how attention has been paid to the middle tones of parts of the bottle, the top edge of the book, the darker side of the jar and part of the foreground. At the same time the shadow side of the book-cover and the background behind it have been gently modified.

Now comes the final stage, and this entails the careful placing of the very light colours into the bare areas disclosed by the initial wiping-out. It also entails making last adjustments, but not many, to those parts already painted. Care is needed at this stage to avoid the inclusion of any unnecessary detail which would destroy the essential softness and unity of the subject. To assist in maintaining this desirable merging quality it is a good idea, in the very last stages, to use a clean and constantly wiped brush to soften many of the edges where two colours meet. In *Colour Plate 24c* the inclusion of the highlights and a little general softening have brought the study to a conclusion.

Many readers may want to copy my illustrated example. Although there is no real objection to this, as it will help to improve technique, it is far better to set up your own group or to re-paint parts from previous works where it is felt that this method of working would prove more successful. Whilst in no way being slipshod or casual, it is a good plan to work fairly fast, for this will develop the talent for looking at the subject with an

'overall' eye. Keeping the practice pieces to about 10in × 8in (25cm × 20cm) should help in making quick progress and avoid getting too involved and fussy. The larger studies can follow once the technique has been learned.

Finally, to show how useful the method can be when painting a suitable subject, *Colour Plate 25* shows a night scene which made full use of the possibilities of the 'wiping-out method'. In the early stages the canvas was covered with a dappled application of blue-greys and brown-greys: it should give food for thought.

Painting with a knife rather than with a brush is yet another method of working. Because oil paints have such a soft creaminess and can be handled without any trickling or running, they are extremely well suited to being applied and spread with a knife. It is certainly not a method for beginners, as it needs experience of colour mixing and a rather sure and bold approach – once the colour is applied it should, with only occasional exceptions, be left to glow and sparkle in all its freshness. There is a quality about knife-paintings which give them an immediate appeal. They have a most satisfying texture, a spontaneity of approach, a freshness of colour and a great sense of unity. They are also most exciting to do and, particularly if your work is getting a little too fussy, I very much recommend that its possibilities be explored.

Strangely enough the universally accepted term 'palette-knife painting' is incorrect. The palette knife is the normal straight-bladed knife with which we scrape and clean our palette. Although this was probably used originally, before it became a really effective tool certain modifications clearly had to be made. These evolved gradually until we now have a slightly different type of instrument which strictly speaking is a 'painting knife'. The main difference, apart from variations in the shape of the blade, is that the painting knife has a double right-angled bend in the shaft. This not only makes for much easier handling, but it keeps the fingers away from the wet surface and prevents knife painters from being instantly recognized by their multi-coloured knuckles!

As few people have quite the same sense of touch, take care when purchasing your knife that its spring and suppleness is suitable to your hand. Also consider the shape (see *Figure 22*). My own preference is for a fairly stiff blade with sharp angles at the shoulder, for this allows maximum contact with the painting surface; the more rounded shoulders make it difficult to judge how much of the blade's edge will make contact. So the choice is important, and those who tell you to make do with an old cake knife or some discarded kitchen implement should be graciously ignored. You stand a much better chance of success with the proper tools.

Once you have your knife I would seriously recommend a few practice pieces first, perhaps on the lines of the trial piece in the monochrome shown in *Figure 23*. A start was made by putting

Figure 22 The painting knife and the various available blade-shapes.

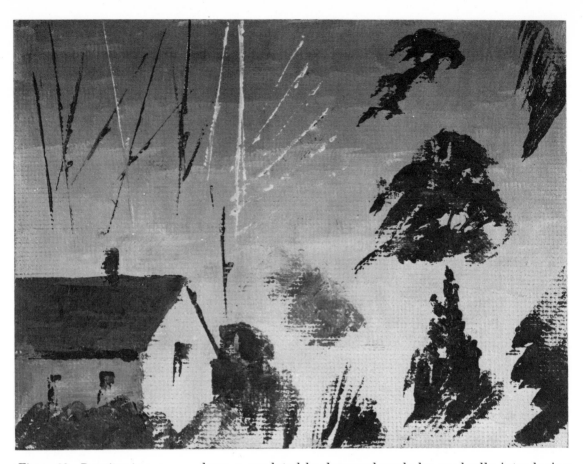

Figure 23 Practice pieces to explore the possibilities of knife techniques.

down a gradated background made by gradually introducing more and more white paint. Each mixture was made on the palette, and placed down and spread with a series of quite broad but gentle strokes, taking care to completely cover the surface. Care must also be taken to be thorough when mixing on the palette, for it is very easy not to include paint from the bottom of the mix and this results in rather unpleasant streaks. Below this first application was placed a series of mixtures slowly becoming lighter and lighter. These were merged, again with gentle strokes, but not so overworked that the rather pleasing knife-marks were completely smoothed out. Over this I tried a series of fine lines, made on top of the wet background and making use of the sharp edge of the blade. I then tried a few more solid areas, some of which were on top of wet paint and others into an area which had first been wiped out. The possibilities will soon become self-evident and working without a multitude of colours makes it a little easier. The main difficulty lies in making and controlling shapes with an instrument which, at first, seems so much less versatile than the brush. However it soon becomes apparent that much more is possible than was originally imagined and even the limitations help to maintain a cohesion of style and a broadness of approach.

With a little more practice it will be found that the soft edges so necessary for horizons and distant features can be effectively achieved by slightly 'dragging' the paint and chattering the edges where two areas meet. By laying one colour directly next to another, or even over it without any agitation, a crisp and firm edge will result. The direction in which you wish to make the stroke will largely determine which edge of the knife is employed when lifting paint from the palette. For a stroke going from left to right, or upwards, the paint will be lifted with the left-hand edge; a stroke going from right to left (or downwards) requires the use of the right-hand edge.

Now try using the normal range of colours. Find an uncomplicated scene, rather like that shown in *Colour Plate 26*, which is composed of fairly definite areas, and see if these can be suggested in a direct and simple manner by smoothing on the paint almost as if carefully spreading butter onto bread. In my sketch I first put down a very nebulous drawing, just to help with positioning. Because knife painting is a very direct method and rather in opposition to the usual practice of building up gradually, it is usually best to start working from far to near. Therefore I started with the sky, mixing the colour carefully and applying it boldly. Once the first knife-load was exhausted I lifted more paint and carried on, gradually lightening and changing the colour as it neared the horizon and taking it slightly below the line which would mark the tops of the distant trees. It has already been pointed out that it is a good plan to paint slightly beyond the edges of areas which will later be nearer objects, for it gives both a better coverage and a softer edge. The various belts of trees were put in, the distant ones first, and although a little merging took place occasionally, great care was taken not to overdo this for it is best to leave the work alone once it has received the paint. In this way crispness and freshness is maintained. Endeavour to use as much of the blade as possible as often as possible; far too many knife paintings are spoilt by stippling and fussing about with the very tip of the blade. Remember always to wipe the blade quite clean before changing to a fresh colour; a roll of soft toilet paper suspended from the easel can be useful in keeping you, the knife and the painting all sparkling, clean and fresh.

Much of the true quality of knife painting, apart from its vigour and richness, is the facility it has for expressing the simple in an original manner, and the complicated with delightful simplicity. These are things that do not come to the hand by magic and just as much thought and care should go into sketches and preparation as into any other work. Particularly if the subject is complicated, care must be taken to translate it into terms suitable for expression with the knife. Knife painting can be used in a variety of ways, ranging from one in which the strokes are bold and vigorous, with deep ridges, to one with strokes that, although still visible, are caressingly gentle. It can be used over a normal thin underpainting, or over a thicker one

if small patches are wanted showing through to give added variety to the work. In the latter case be sure the underpainting is dry and that there are no bumps and ridges as these tend to catch the blade and impede the smooth flow of the work. Knife painting can also be used in conjunction with brush painting, but my own opinion is that in the majority of cases one should keep to one method only, otherwise the work can easily look disjointed and uncoordinated.

For my last example, *Colour Plate 27*, I have included a work which was made in the studio from a series of notes and sketches made on the spot. It was completed with my normal working palette and it includes many of the strokes, techniques and observations already discussed. The little figure, which I considered important to give a sense of scale to the depth of the hillock, broke my own rule for it was put in, right at the end, with a brush!

Experiment with the knife; even if it proves not to be the best method for you, it will help to bring a controlled looseness when reverting to brush work and give your work a pleasing free-flowing certainty of touch. Should it suit you, however, you will have to hand a style of painting which is clean, fresh and vigorous, and capable of infinite interpretations and variations.

10 Composition

Nature is a generous benefactress, giving artists a multiplicity of subjects in a wide variety of mood. Admiration must be tempered with a little caution, however, for she is so notoriously over-lavish with her gifts that seldom is a complete and ready-made design presented. Almost invariably the display must first be noted and a portion of it selected. After this it may still be necessary, in all humility, to make adjustment to the size, shape and grouping of the chosen items. A satisfactory composition often needs such selection and rearrangement. One that is unsatisfactory generally means that such considerations have been ignored or overlooked and the work has either an over-abundance of cloying sweetness, or unacceptable weaknesses in the grouping of the various shapes and masses.

The very first thing to consider is the shape or proportions of your board or canvas and whether, for some special circumstance, it needs to be changed or modified. By far the most popular and acceptable proportions, particularly for landscape work, are somewhere near a ratio of 5:4. Occasionally one sees long narrow paintings and sometimes square ones, but the horizontal 5:4 rectangle is the commonest shape. This is no doubt governed by the positioning of the eyes which, provided the view is not restricted in some way, have a greater field of vision horizontally than they have vertically. This does not mean that changes should never be attempted or will never be successful, but it helps to realize that the upright view works well only when the field of vision is restricted either by the close proximity of the subject or by a most dominant vertical accent in the whole design. This is borne out in portraits, many flower pieces and a large number of architectural studies. On the other hand if the view is open and unconfined, as it is in the majority of landscape work, then the horizontal rectangle must surely remain the firm favourite.

The most fundamental rule of composition is one that has already been mentioned in the discussion of skies, namely to ensure that the balance of earth to sky should not be equal. Indeed one could go further and state that any definite line which cuts the picture in half, vertically or horizontally, is best avoided. The result is division rather than unity. By the same

reasoning the focus of interest, an essential part of every painting, is far better if placed a little to one side of centre. It is here we can learn a lot from photographers, who make use of a simple rule to help with their compositions – which after all, cannot be modified quite as easily as those of the painter. They call it the 'Rule of Thirds'. The picture area is mentally divided into three in each direction, rather like a noughts-and-crosses chart, and the focal point designed to be a little towards the centre, near where one of the verticals intersects one of the horizontals (usually the lower). There is no need to be rigidly mathematical about this, for every rule ever made can, with knowledge and experience, be broken. However, it is still a useful general principle as can be seen by the sketches shown in *Figure 24*; in each instance an improvement has been made by placing the centre of interest a little to one side.

Another important consideration is the help given in creating both depth and unity by allowing one object apparently to overlap another. If one were arranging furniture in an empty room, it would be strangely uninteresting to place each item against the wall, so that the whole of each could be seen the whole of the time. The effect would be much happier if the view of one piece was occasionally obscured by the careful placing of another. The arrangement then has a greater linkage, unity and rhythm and the visitor is more encouraged to walk into the room. So it should be with painting. The feeling for recession and unity can be greatly helped by finding a viewpoint where such overlapping takes place. Occasionally one may need to change the placing of certain things but more often than not there is no need for a fierce session of uprooting and transplanting. Improvements can often become apparent by just walking a few paces to the left or right; occasionally no more is needed than a slight movement of the head for the scene to become quite transformed. An obvious example of the improvement obtained by overlapping is shown in *Figure 25*.

Everyone learns from their own mistakes and from the advice of others, till eventually risky or dangerous situations can often be anticipated. Certainly this is true with painting, and I plan to explain some of these dangers that have a particular bearing on composition. Some readers will be aware of many of them; others may find them a useful warning to prevent good work being marred by a failure to anticipate one or other of these snags.

The first of these, shown in *Figure 26a*, is closely connected with the points made about overlapping: the sketch shows the inadvisability of allowing any single line to start by marking the edge of one area and to finish by bordering a different area. This can be seen particularly in the first sketch where the placing of the telegraph pole is very confusing because it is in direct line with the edge of one wall at its base and with another wall at its top. A careful look will reveal ten such mistakes in the first sketch and they have, by careful arrangement, all been

Figure 24 It is seldom satisfactory to place the most interesting feature in the centre of the picture. The centre of interest should be a little to one side of the point where one of the horizontal 'thirds' intersects one of the verticals.

Figure 25 A composition which includes a view of complete and separate components can be considerably improved by changing the viewpoint for one which allows them to partially obstruct each other.

avoided in the second. Perhaps a good way of avoiding similar errors is to remember the advice of one of my former tutors: 'Never let one line perform two jobs'.

It is seldom a good idea to include anything which leads the viewer's eye out of the painting. This can successfully be avoided by slightly changing the viewpoint, as is shown in *Figure 26b* where an obvious improvement was made by making the path lead into the scene rather than allowing it to invite us to look at the painting next door. But there are times when the correction cannot be made as simply as this. Everything looks right except for the obvious arrowhead which so distractingly points out of the picture. This has happened in the left-hand sketch in *Figure 26c*. In such cases the picture can usually be helped considerably if some kind of strong vertical accent is included so that the point of the 'arrow' is blunted and the eye is halted and so contained within the picture area. In my case a nearby cypress tree was moved a little to the left and brought into the scene. In non-technical language this is often referred to as a 'stopper'.

Two things are needed to improve the left-hand sketch shown in *Figure 26d*. The first is the position of the boat, which would look much happier if its mast was angled to point towards the centre rather than towards the edge. A good point to remember is that it is usually best for sloping things to point into the picture. The second unhappy note is the tree-trunk which seems to be a little shamefaced about daring to intrude; it helps to give a greater rhythm and sense of containment when enough of the tree is included for it to stand and do its job less apologetically. Such rules are not hard and fast; one has only to think of Degas' beautiful ballet scenes, where a head, a hand or a foot peeps delightfully round the edge, to realize that the half-seen feature can be most effective. But such things are only done after considerable thought and to produce a particular effect; the rules have been broken *purposely* and the results are evidence of the knowledge and confidence which prompted such originality.

100

Almost without realizing it one can quickly fall victim to emphasizing the least attractive features of a scene. It is almost as if they are bullying us into making a completely accurate record and thereby robbing us of any opportunity to make minor artistic changes. One is often so concerned with the difficulties of colour and atmosphere that problems of composition become less and less obvious. Any scene which has a considerable number of similar objects is a particular danger in this respect, for too much repetition can easily result in monotony. In my example, *Figure 26e*, I have tried to show how an equally spaced row of trees of the same height can be improved by making variations in both size and spacing, but the same kind of improvement can be made when dealing with any group of similar objects. A particular offender is the very neat fence which sits along the bottom of the picture – almost grinning at you like a row of dentures. Consider carefully if its inclusion is necessary, for the painting may well look better without it. If it really is needed, it will look far more effective if a carefully thought-out irregularity of size, grouping and direction is somehow introduced.

The difficulties of the vertical composition have already been mentioned, but on occasions an upright interpretation is the only answer. In such cases the thing on which to concentrate and on which to place the greatest emphasis is the obvious verticality of the main features. Although certain horizontal accents are needed for contrast and balance these should be kept to a minimum; failure to do so can easily lead to an unpleasant 'ladder effect'. This is particularly noticeable when long vertical masses on each side are linked by a series of horizontals all the way up the canvas. My example in *Figure 26f* shows the results of such unfortunate positioning; the consequence is that the little Provençal street loses much of its appeal. By retreating a few yards the gap was closed, there was more room for the high buildings and the horizontals became less dominant. Even so, care was taken to modify the regularity of these by deleting the rather strip-like clouds and giving a radiating effect to the telephone wires.

Even beautiful trees can sometimes be a little monotonous in their growth and structure. The bare tree, which at its best reminds us of intricately patterned lacework, can often be helped a little, particularly if the joints where branches meet the trunks are either symmetrical, and very evenly spaced, or are unnaturally similar to each other. In such a case, a judicious artistic variation of spacing, or a little intertwining, can work wonders. Similarly a tree in full foliage, beautifully carrying its soft and swaying masses of leaves, can also be subtly altered. Often such beauty is marred because, seen in silhouette, the tips of all the masses, if joined, form a perfectly straight line. As the dead straight line is most unusual in nature, to record carefully such a tree would not make for a picture as evocative of nature as we would desire, and it would be far better to fluff out some of

Figure 26 COMPOSITION

a It is best to avoid allowing the edge of one object to become the edge of another.

b Endeavour to lead the eye into the picture rather than out of it.

c If it is not possible to implement (b), the eye can be contained by including a strong vertical feature.

d Half a tree-trunk is seldom satisfactory, and the sloping mast looks better when directing the eye into the picture.

e A little reshuffling can often prevent boring repetition without destroying the essence of the scene.

f With vertical compositions care must be taken to avoid a 'ladder' effect. In this case I moved back to give greater verticality and took liberties with the horizontal accents.

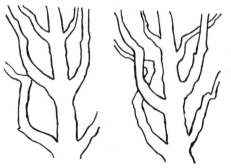

g Bare trees (left) look much more effective if irregularities and overlapping are emphasized.

h Trees in foliage (right) look better if the line of their silhouette is not straight and continuous.

the masses so that a much less straight and more natural silhouette was presented. The diagrams in *Figure 26g* and *26h* explain the sort of things to look for and give possible corrections.

Having paid considerable attention to composing and arranging the subject, one is immediately faced with the need for the ability to draw. This by no means suggests that a painting is merely a coloured diagram, but even in the most broad and loose painting certain accents must be accurately recorded if the work is to hold together and register with any degree of conviction. Who wants a lovely landscape registered in delightful patches of colour if one's appreciation is ruined because a roof slopes the wrong way, resulting in a feeling that it was built with triangular bricks rather than rectangular ones? Or who wants to see a fence that, through an elementary fault in drawing, looks about eight feet high in the distance and is so small as it gets nearer that it would be only a minor obstacle for an underfed duck? Freedom and originality can come only with an understanding of drawing and never by ignoring it. That is why the sketch-book should be a constant companion, and by its use (coupled with a keen eye) a fund of knowledge and information is gathered which will immediately come to the aid of the hand when the pencil is changed for the brush. Drawing for a painting is different from doing a drawing for its own sake for it has to be expressed in painterly terms; but its need is always present. To imply that one does not need to draw to be able to paint seems to me wrong. All one needs to do, we are told, is to paint the patches the right colour and all will be well – just buy your paints and let the inspiration ooze out. At the outset this may be exciting but as soon as any real advancement is sought it quickly becomes evident that such a method is a very fast route to disappointment and despair. The elements of drawing in any painting, be they only a few subtle, minor accents, are of extreme importance.

Perspective is perhaps the greatest of all the drawing problems that confront the leisure-hour artist, but it must not be shirked since, in one form or another, it enters into every painting. Without going into long and complicated theories, the basic fact is that a series of lines that we know to be horizontal and parallel seen on (let us say) a building directly facing us, appear to spread out like the ribs of a fan when the building is viewed from a more oblique angle. The joint of the fan is always furthest from us, with the ribs becoming more widely spaced as they get nearer. When working on a scene which includes any kind of building, I concentrate on trying to record very accurately one line at the top (the ridge-tiles or the eaves) and another near the base. It is also wise to have a perfectly horizontal line at eye-level which, if you are on level ground, is about three-quarters of the way up a doorway. Once you have these established the rest will follow almost automatically. This sounds very simple, but a surprising number of people find great

difficulty in deciding exactly which way a certain feature tips – which end goes up and which goes down. If this proves problematic, do not despair, for many prominent artists have publicly admitted that such problems also bother them! A very simple method of finding out which way something seems to slope is to hold a fairly long pencil horizontally between the finger-tips of each hand. If it is kept perfectly level and at arm's length it can be brought up slowly until it appears to touch some important feature – say the corner of the eaves or the line formed where the base of a building touches the ground. It then becomes immediately apparent which way the roof or the base-line appears to tip.

An improvement on this idea is a simple gadget which can be made easily with two strips of fairly stiff card joined at one end with a stationer's rivet. You then have two long arms which swivel open like the blades of scissors and, if the joint is made stiff enough, these will remain fixed in any position. *Figure 27* shows the gadget in use. Label one arm 'Keep Horizontal' and this will remind you that it must be kept absolutely level. The other arm is swivelled up or down until it appears to run along the troublesome feature. Providing this gadget is kept absolutely 'square' to the body you will then have the correct angle. Bring it down to your sketch or canvas and you can immediately transfer an absolutely accurate guide-line to your

Figure 27 Two strips of card, with a tight yet movable joint, can be of considerable help when transferring difficult angles from scene to paper.

105

work. It has other uses too, for with a little improvisation it can be most useful for ascertaining the correct pitch of a roof or the steepness of a church spire.

Whilst agreeing that an understanding of the principles of linear perspective is useful to the artist, this does not mean that it has to be studied in such depth that it becomes a mathematical exercise. The knowledge of the subject should merely be sufficient to enable the painting to be reasonably accurate whilst still maintaining the essential feeling for free and personal expression. Taken too seriously, an overdose of perspective is liable to cover the work with construction lines and produce a result which is tight, fussy and lacking in individuality. Too much freedom, on the other hand, and not enough knowledge can produce a different but equally displeasing result. To strike a balance, there are certain rudiments which it is essential to know; they will greatly improve the powers of observation and allow the artist to be selective with much greater certainty.

Figure 28 By associating the position of boxes on shelves with the siting of buildings in a landscape you will be helped towards an appreciation of the basic principles of perspective.

The first is to recognize and establish the eye-level or horizon line. All horizontal lines, which are *above* this (other than those directly facing you), will appear to slope *downwards* and converge on a point somewhere on this line; all horizontals which are *below* it will appear to slope *upwards* and converge at the same point. This is further explained in *Figure 28* which shows, in the middle row, a box and a house where the eye-level is at a point a little above the base; in the top row the objects are well above the eye-level whilst in the bottom row they are decidedly below it. *Figure 29* shows the theory put to the test in a small scene. The left-hand view is from ground-level and the right-hand one is from an upstairs window. Notice how the eye-level changes and notice also that in the right-hand sketch the lines which mark roof-top, eaves and base-line all converge in an *upwards* direction towards the horizon, whilst in the left-hand sketch it is only the base-lines which slope up to the eye-level; the rest all slope down. The significance of an earlier statement now becomes a little clearer: if the highest line, the lowest one and the eye-level one are firmly established the rest fit in almost automatically – but it is as well to realize exactly why this should be so.

So far we have dealt with buildings sited on level ground; a road which runs uphill or downhill presents further complications. The downhill view is extremely confusing and difficult because, somehow, the impression must be given that the far end of the road drops *down* and yet it must be shown by lines which run *up* the canvas. A small but important observation that always helps is to take note that when a building is erected on sloping ground, a wedge-shaped platform must be built to ensure that the base and the rest of the structure is level. If the road slopes downhill the sharp end of such wedges point towards you; if the road is uphill then any such platform points into the picture. This can be seen by studying the two sketches in *Figure 30*. It will also be seen that in the downhill sketch the lines of the road will converge at a point *below* the normal eye-level line, whilst in the uphill scene they converge very much *above* it.

A couple of final points concern arches and spires. Difficulty is often encountered in making the spire appear to sit accurately on top of its tower, and the reason for this is the strange temptation to put it off centre once the view is anything other

Figure 29 The general aspect and perspective of a scene alters considerably if the viewpoint is changed from one at ground-level to one at a more elevated position.

Figure 30
a In this uphill scene the road
appears to converge at a point
well above eye-level.

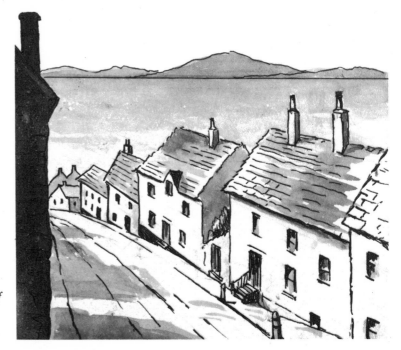

b Conversely when the point of
convergence is much below eye-
level the road appears to be
going downhill.

than a full frontal one. The position of the viewpoint in fact matters very little, for the spire will always be directly central to the complete width of its supporting tower. In *Figure 31* I have imagined the tower is transparent and have joined the corners with diagonals to give a base for a central rod. As you can see, in each of the three viewpoints the position of the spire remains unaltered.

A side view of arches also presents problems for it can be quite difficult to prevent the curve from looking as if it is liable to collapse. Again the diagonals from ground-level to the base of the arch will help, because these will give the correct optical centre and it will soon be seen that the curve on one half is very different from that on the other. A comparison with the arches directly facing, which are accurate semi-circles, will serve to confirm this.

Finally, to show how a knowledge of drawing and perspective can come to the aid of the oil colourist, I have included two paintings which would have had little chance of success without it. The first, *Colour Plate 28*, shows the interior of an old barn in Norfolk; the second, *Colour Plate 29*, shows an attractive sketch of a little street in Durham. For the latter, the first sketch was made in daylight, but during an evening stroll I was so attracted by the unusual effects of light from two separate sources, that I made colour notes and painted it at my leisure a few days later. Both works have been included because between them they cover a great many of the points discussed in this chapter.

Figure 31
a Wherever you are standing a spire will obviously always remain directly in the centre of the complete silhouette of the tower.

b Only those arches directly facing us are semi-circles. Those seen in perspective are composed of two quite different curves.

11 Introducing Figures

From Dymchurch to Dundee and at points around, beyond and between, artists are setting up their easels, precariously balanced in inaccessible places, to record, in a wide variety of media, countless farms and barns, streets and creeks, boats and bridges, trees and terraces, valleys and vistas, mountains and masterpieces. They will consider long the effects of lighting, and study carefully shapes and masses to ensure a well-balanced composition. The foregoing ingredients are absolutely essential; but occasionally might not a human figure be carefully placed in the scene? Not every subject demands such an inclusion and on occasions a figure would destroy the sense of peace and seclusion; but many paintings convey a quite unintentional feeling of loneliness and emptiness due to the lack of any sign of life or animation. The work of many Art Societies forces one to conclude that nearly every picture was either completed on a Sunday morning before even the milkman had arrived, or depicted an area whose population had been the victims of a virulent plague or some strange, rigid curfew. The judicious placing of a figure or two would have immediately brought an element of active involvement to the scene. In most cases the composition would also have been improved because the verticality of the figures would have cut across any strong horizontal features and thereby helped to keep the viewer's eye within the picture area.

What has been said of figures is equally true of other things which help to bring a sense of involvement into the scene. Vehicles are often a great nuisance to the artist, as their owners seem to take a wicked delight in parking them in the exact position that restricts most of the view. On the other hand, with a little thought, their careful placing in a picture can be a considerable aid to composition. The same can be said of animals, bicycles, or indeed any object that is extremely familiar to the viewer. Such familiarity is important, for it creates both a link and a comparison with surrounding features. Everyone knows the size of a figure, a cow or a car and can immediately relate its size to those of adjacent objects. In painting a rock-strewn beach, for example, it is not until a figure or two is included that the size of the rocks can be truly

appreciated. In the same way a very large doorway immediately becomes all the more imposing if it is compared with a figure placed nearby.

Perhaps many artists exclude figures because they feel that, although they are fairly competent at landscape painting, their knowledge of portraiture is too slight. Some skill at portrait and figure work is helpful, but lack of it need not necessarily act as a deterrent, for what is usually needed is merely a suggestion rather than a definite statement; often little more than a carefully placed tapering vertical stroke with a knob on top will translate quite adequately. This cannot be too casual: the stroke and the knob have to be of the correct height and proportions, but with a little care and study such 'carefully careless' suggestions blend into and become part of the scene very successfully. A carefully detailed tiny portrait would look too much like a cut-out, offensive and unacceptable.

Near to my home is a country lane, and set into the grass verge, on the brow of a hill, is a free-standing postbox. It is merely a rectangular red box screwed to a cylindrical post about five feet high. As one drives up the hill it is seen in silhouette and one is constantly fooled into thinking it is someone about to cross the road. The illusion is encouraged by the fact that the box is fixed so that a little of the post appears above it, and at first sight they combine to look exactly like the head, shoulders and body of a figure. If such a simple suggestion can 'read' as a human form there is surely little need for a detailed rendering, particularly when, in a painting, it will only be between one and one and a half inches (25mm–35mm) in height.

The talented designer of the dust-jacket of my previous book supplied an extremely good example which is reproduced in *Colour Plate 30.* He chose my painting of a church just outside Canterbury and then decided to include, as an example of brushwork, close-ups of the two figures walking along the path. In the original the figures are quite small, for the whole painting only measures 20in × 16in (50cm × 40cm). For this reason they were painted with a minimum of detail but, set as they are in the midst of the landscape, the eye accepts them quite readily. In the two close-up views one can see that although the proportions are reasonably accurate, they are painted into wet paint and look, when enlarged, almost casual. But no real advantage would have been gained by working with a magnifying glass to paint them with great detail.

Although close inspection of the figures included in many successful paintings may reveal them to be rather casual and uncomplicated, such apparent simplicity does not come to hand without practice and an understanding of a few basic truths. Just as we have seen that there is no need to master any but the fundamental principles of perspective, it is also true that for these purposes an exhaustive study of the figure and its anatomy is not essential. There must, however, be sufficient feeling for the living figure to ensure that, no matter how

loosely it is treated, the indication looks both correct and acceptable. It is not so much the details of fingers, hands and features that need concentration, but the essence of a solid being, living in space and subject to all the usual effects of light and atmosphere.

First, it is important to bear clearly in mind the general proportions of the average figure; one has only to make the small oval, which is to represent the head, just a little too large for the whole figure to look strangely deformed and grotesque. Using the head, from crown to chin, as a unit, it will be found that it goes roughly eight times into the complete height of the average human figure, as can be seen in *Figure 32*. Only if a greater dignity is needed for the figure should the proportion be increased. Less than one to eight will make the figure appear shorter, as is the case with children. Observe that from a frontal view the shoulders are three heads wide, the waist-line is three heads down and is in line with the elbows. The length of the whole leg is approximately half the height and the extended hands reach half-way down the upper leg. Of course these are merely average proportions, but it is well to have them in mind so that you are more prepared to observe and remember variations when sketching or watching people around you. It is particularly interesting to see how much these variations help in conveying the characteristics of each individual.

Figure 32 (above)
SKETCHBOOK PRACTICE
Always keep the general
proportions very much in mind.

Figure 33 (right and opposite)
Start with silhouettes and
gradually introduce any
necessary changes of tone.

112

With this information in mind, I would next recommend lots of sketch-book studies, endeavouring to make them as rapidly as possible so as to capture the characteristics of the figure before it moves. Should you be fairly new to such activity I think it wise to use a fairly soft pencil or a fibre-tipped pen and to start with silhouettes similar to those shown in the top row of *Figure 33*. This will encourage the eye to search for the solid shapes of the masses, which is much more in sympathy with the application of paint than is a rather tight linear drawing. More importantly, it will avoid the temptation of trying for the inclusion of detail instead of the desired broad and general effect. At first try standing figures, but avoid the effect of a row of rigid guardsmen. A good plan is to look at people who stand and wait or chat in queues, bus stations, and market-places, and to try recording the wide variety of their postures and positions. Once that comes more easily, attempt sketches of people leaning, lounging, working, sitting and reclining. Occasionally try arranging the figures into small groups and clusters, where one shape overlaps another, as this often creates an added interest. Do not worry unduly if figures go wrong at first – just turn from the failure and have another try in the next available blank space; failure now is far better than attempting to paint them straight into your picture and continually having to wipe them out. Working away at this silhouette method develops the

facility for capturing the proportions and pose of the figure surprisingly quickly.

Animals present difficulties because they are nearly always on the move. They are well worth some attention, however, for their shape and colour often give contrast to the composition and their inclusion can be helpful in preventing the farmyard from looking too deserted and derelict, the road from looking unused or the meadow or moorland from seeming depressingly lonely. Do not worry about their constant movement – if their position alters too much, leave the sketch unfinished and look for another pose. Even the unfinished studies eventually build up in the reference library of the mind, later to agitate the hand and brain into action.

A little practice of this kind will soon make you aware that not always is the figure a dark silhouette against a light background, though such an introduction is both valid and valuable for it encourages vision in terms of solid strokes and areas, more akin to an oil-painting technique than is a purely linear drawing, however delightful that may be. The next step is to suggest any changes of tone, which will not only give an indication of how the figure is clothed, but will also show something of the effect of light and how it modifies the general nature of the background. A little variation of tone could be brought into the sketches, carefully but still broadly, in a manner similar to that shown in the lower half of *Figure 33*.

Paintings that include figures often for some reason do not look quite right; there is a feeling that somehow the people in them do not truly belong to, or become part of, the scene. There are two very common causes for such a lack of credibility. The first is that insufficient attention was given to the size of the figures in relation to the surrounding features; the second is that the all important eye-level of the artist was not constant throughout the painting.

To deal with size and scale first, it is essential that the figures are not out of proportion with their immediate surroundings, for to have them too large or too small defeats one of the main reasons for their inclusion. Should figures wander into view whilst painting is in progress, it is an excellent idea to make tiny marks for the position of the head and feet. Even if they wander off they can now be included: the correct scale will have been registered. This is most important, for it is all too easy to find the carefully painted figure appears to have the proportions of either an under-nourished pygmy or an over-developed giant! Another good plan is mentally to move figures across the canvas so they can be compared with something whose size will help in making a simple comparison. Doorways are particularly useful for this purpose, as is demonstrated in *Figure 34*, for most doorways are about one head higher than the average adult person. Such knowledge was very useful when putting in the figures in the lamplit street in *Colour Plate 28*.

Figure 34 *Always check, by noting position of head and feet, that the figure is of a correct scale.*

114

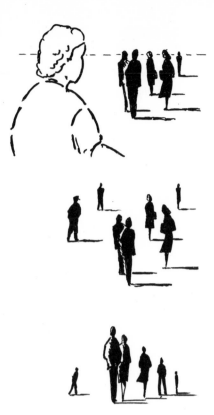

Figure 35 The eye-line (or head-height) of the figures alters according to the elevation of the viewpoint.

It is also extremely important that the eye-level used when painting the scene should be kept the same throughout the work. Overlooking this can cause strange results and it is a surprisingly easy trap to fall into. It is well to remember that if you are standing on level ground, the eye-line of every standing figure will always be at approximately the same level; the more distant ones appear smaller, and the higher position of their feet also explains that they are further away. This is shown in the first diagram of *Figure 35*. Were I to climb to an upstairs window to view a similar group, I should see that although the distant figures again appeared to be smaller, both the head *and* feet of each was a little higher up the paper as they gradually receded (see *Figure 35b*). If I get down to a very low viewpoint the feet of near and distant people are almost on a level and, from this position, it is the heads which appear to be lower and lower as they recede. This kind of observation is also useful when placing figures on uneven or sloping ground, where adjustment must be made to allow for the slope.

If you are fairly experienced you will quickly be able to start painting the odd figure or two into your work. Remember the above points, and never neglect the opportunity to continue making quick sketches, for they will prove invaluable as reference for subsequent pictures. They will also provide a wealth of ideas. On the other hand, if you have done little or no figure work, I would now strongly recommend a few coloured practice pieces in oils. Paint in a rather neutral middle-tone background on an odd piece of oil-painting paper, covering it fairly well with an opaque coat. Into this the first silhouette-type figures will be painted and, initially, I suggest you make them three or four inches high (7cm–10cm). Taking a hint from the wiping-out method, use a rag to wipe out roughly the shape of the figures and then, with any rich but dark colour, paint in your figures. The idea of making them large at first is to help you to keep reasonably accurate; to be a couple of millimetres out on a fairly large figure is not too disastrous, but when dealing with something perhaps only two thumbnails high, such an error would be a calamity. Try three or four of these larger figures first and then at the side of them try repeating them but at about one-third of the height, bringing them down to the size usually associated with figures in the landscape. The only remaining hurdle now is to try to paint them directly onto and into the wet paint without first indulging in any wiping-out. For this a smaller brush will be useful, and I use a flat sable No.8 which is only about a quarter of an inch (6mm) wide. By constantly wiping the brush, wet paint can be transferred on top of wet paint quite successfully. The flat brush seems to me to hold the paint better than a small pointed one.

I should perhaps state my reasons for advising that figures in landscape works be kept fairly small. What we want is a landscape decorated, enriched and enlivened by the inclusion of figures: for that reason they usually look far better and less

115

dominant if placed in the middle or far distance – they are really only a supporting feature, albeit an important and useful one. To have them very large would be to reverse the order of things; the work then becomes a portrait with the subsidiary support of a suitable landscape, while what is wanted is a landscape story suitably backed up by the inclusion of unobtrusive but necessary signs of life.

To return to our practice pieces. After completing a few all-silhouette figures, try a few with some subtle changes of tone. *Colour Plate 31* gives a good idea of the sort of thing to try. These examples of the type of simplified figures which are very suitable for landscape work were kindly loaned by my friend and colleague William Vickers of Rotherham. He too recommends the silhouette studies first, and suggests the tiny one after the larger one. Although Mr Vickers is a very able portrait painter, in landscape work he too believes that figures are best kept small by placing them well into the scene, and they translate far better if painted with a considerable economy of treatment. These sketches show that portraiture is indeed a branch of art quite distinct from that of the placing of figures into a landscape.

After a few pleasant sessions of such practice work you should be well prepared to populate some of your paintings and thus prevent much of the unintentional sense of desertion and loneliness. The figures should be incorporated as the work progresses, for it is usually more satisfactory than trying to put them in at a later date. There are two further good reasons for the inclusion of figures. The first is that they create a contrast of tone or colour and thereby help to maintain a sense of balance. The second is that they tend to lead the eye, and stimulate the imagination, towards the direction in which they move and this not only attracts attention to themselves but creates a greater interest in the particular area of the painting in which they are placed.

Having discussed the general principles of putting figures in landscape, it may be worth considering their introduction into existing work. This is often a little more difficult than it sounds, which accounts for my recommendation that they be painted in as the work progresses. The need to include them later, however, may arise and there are two hints which I have found very useful. One is to draw the figure onto the dry painting with a little pastel of the proposed colour. This allows an assessment of their general suitability and siting without any firm commitment. If they look right they can be flicked gently, leaving only slight traces of pastel which will be absorbed when the oil colour is applied. If they look wrong they can easily be wiped out, leaving no trace.

A second method has proved extremely useful: to make use of a sheet of glass which is placed directly in front of the dry painting. The figure is then painted on the glass and its suitability can immediately be assessed. Should any slight

adjustment of placing be needed, the glass can be moved around a little until the best position is established. Once a decision is made it is a simple matter to make a mental note of the position of head and feet, remove the glass complete with its painted reference, and proceed with the painting of the figure. As my own preference is for painting such figures into wet paint rather than dry, I either 'oil-out' the chosen area by smearing it with a minute amount of linseed oil, or better still, repaint this portion of background with a meagre coating of carefully matched colour.

12 Facility with Foregrounds

The effective and successful handling of the all-important foreground area is much more difficult than is generally realized, for only the merest understatement or over-emphasis is needed to destroy the essential linkage it should have with the rest of the picture. Before dealing more explicitly with the many problems involved, let us look briefly at what is probably the most common cause of the foreground becoming displeasing and unacceptable. Referring back to the diagram in *Figure 18*, page 57, acts as a reminder that in the foreground we find not only the purest and richest colours, but also the darkest of darks and the lightest of lights. Unfortunately this is often overlooked and the colours become sullied and muddy, and the essential tonal contrast lapses more and more into a non-commital middle tone. The result of this is that the lowest part of the painting either tends to merge into the middle distance or appears to want to slide downwards out of the picture. The essential quality of helping to make the items of the foreground appear to come nearer and nearer gets completely lost. This could, of course, be due to a failure to observe and appreciate the scene properly, which re-echoes the need for those all-important preliminary sketches, but more often than not the cause has a much simpler origin: haste or over-keenness when painting.

Often all goes well until the later stages. In the normal landscape study the usual procedure is for the sky to be painted first, then the middle distance, and lastly any foreground features. Unfortunately, by the time these last stages are reached, the palette has become plastered with mixtures, making it extremely difficult to find a clean area on which to mix the important rich colours; the brushes are now all rather dirty; and lastly, time presses and one is hastened by either the rattle of tea-cups or the clamour of friends who are anxious to get packed up for the journey home. This is extremely bad for foregrounds. If it is merely time that presses, the wisest plan is to leave the work and finish it later in the studio from memory and with the help of sketches. If it is that the materials have become soiled and dirty, be very resolute and fight off the clamouring temptation to carry on working because inspiration is running white-hot. Take a short break: this will not only give

you time for an appraisal of how the work is progressing, but it will also give you the opportunity to clean up a little. I always make it a practice to carry a few more brushes than I will ever need and also plenty of rag. When I reach those very significant final stages I carefully clean up the palette, put out any extra colour that may be needed and take up two or three clean brushes. All this gives one a far better chance of success.

I realize that in clear cold print such advice seems all too obvious but on so many occasions, when asked to comment on paintings, I have been forced to express regret that the foreground looked so muddy and out of character. If asked why the artist did not pause for a little clean-up, the answer is usually something like 'Oh I don't know – I was so enjoying it all. I realized that everything was getting a bit dirty, but I just couldn't force myself to stop.' Try very hard to pause for a little thought and a general cleansing operation, and many of the foreground problems will solve themselves.

Another simple cause of colours becoming muddy is that the full glare of the sun has been allowed to fall directly on the painting whilst working. Such lighting is so strong that the colours used appear to be very much brighter than they really are, and when the work is brought into the shade they look much less fresh. It is a good plan to avoid such strong lighting on all occasions, but particularly when handling the foreground, when the correct assessment of colour and tone is even more essential.

Those are two valuable general hints, but there are other considerations. First is the need for the foreground features to strike an acceptable and pleasing balance with the rest of the

Figure 36 THREE TYPES OF FOREGROUND
a The conventional approach where the foreground is not over-dominant, thereby allowing the eye to move freely into the picture.

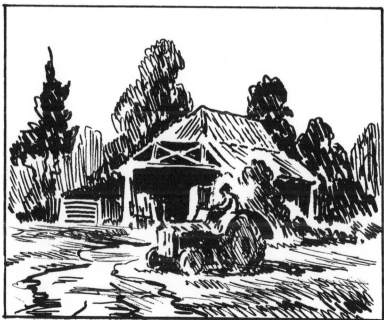

*b Here the nearby objects are
more important and all the
background objects are
subjected to considerable
simplification.*

painting. In the majority of landscape paintings the main aim is
to take the viewer's eye into the picture, the exception being
those paintings where the foreground itself is the main feature,
with whatever is behind included merely to make an interesting
backdrop (see *Colour Plate 32a, b*). In the more usual landscape
scene, the striking of this essential sense of balance is no easy
matter; although items in the foreground must be well drawn
and retain their true qualities of tone and colour, they must
never be so dominant that all our interest is absorbed and we are
thereby prevented from being enticed into wandering a little
further into the scene. On the other hand, should the foreground
become too much of an understatement it no longer serves as a
measure against which the qualities of distant areas can be
judged. It is a difficult balance to strike even for those with
considerable experience. An artist quickly realizes that things
in the far and middle distance, influenced as they are by the
effects of light and atmosphere, can often be adequately
suggested by a fairly free and nebulous treatment. Puzzlement
and hesitation set in when the nearer features demand con-
sideration. These bring not only problems of composition and
selection, but also those arising from the need for a more
positive statement. The realization that such nearby objects are
seen with great clarity sets a trap (into which many fall): to
overstate all foreground matter to a degree which puts it out of
keeping with the rest of the painting. One must be constantly on
guard against this hazard.

Those who are expert with a camera can help in this matter. A
photographer can make a mechanical adjustment to ensure that
the focus is concentrated to give a greater emphasis to the
middle distance, thereby ensuring that nearby objects, whilst

c This large and empty foreground is probably the most difficult, for here the eye has a long way to travel and every stroke must help to convey a feeling of ever-increasing distance.
Similar examples are shown in Colour Plate 32.

still retaining their essential qualities, will not be recorded with quite such a sharp definition. Providing we do not try to copy one art form (photography) and confuse it with another (painting), a study of really good photographs can be extremely helpful when considering the treatment of foregrounds.

Similarly it is a good idea, when viewing the scene to be painted, to look at it rather like a motorist who takes in the whole of the view the whole of the time. In this way the eye naturally gives greater attention to the centre of interest and the scene takes on a far greater unity than if attention is allowed to flit disjointedly from one area to another. Even when allied to considerable skill and expertise in painting, jumping from spot to spot without assessing the relative qualities of each gives the artist little chance of producing a result rich in harmony and concord. It is much more liable to produce a series of quite pleasant but decidedly separate studies, all on the one canvas. By keeping this overall view constantly in mind during the course of the painting, one can, when necessary, transfer attention to the foreground to collect the necessary information for it to have form and structure, colour and tone. With the general atmospheric effects constantly in mind, the foreground will be both harmonious to the whole and have due regard to recessional qualities. The balance will then have been struck. It is not at all unlike telling a successful joke: if the punch-line is either overstated or put in the wrong place, no matter how rich the vocabulary, the effect is ruined.

The painting reproduced on the dust-jacket should help. It shows a view of the back garden of an old friend and fellow-artist, Louis Moreau, who has a traditional bungalow in Provence. The foreground is really the small triangular patch of

rough ground at bottom left, nicely backed up by the little section of wall and the dark tree. It was a great temptation to make a detailed study of these items, for they were very beautiful in the strong southern sunlight. However, I felt that to do so would have denied any invitation to wander further into the picture and so they were painted with a certain economy of treatment. I have followed my own advice in keeping the foreground colours rich and clean and the essential tonal contrast has not been neglected.

So far discussion has been of the more general landscape scene, where it is important to convey the impression of space and distance, but often a subject presents itself where the foreground material is so dominant a feature that it becomes the main interest. In such a case anything behind it plays a minor role, its only purpose to give a credible sense of feeling for depth and volume; the eye does not need so much encouragement to be led further into the scene. In my example in *Colour Plate 32b* it was the very large stone urn and plants, set in the grounds of a gracious country house, that demanded most attention and for this reason the house and trees behind have been played down and relegated to a minor supporting role. Similar instances of dominant foreground features can be found in such subjects as leaves or blossom against the sky, large fences and country stiles, hedgerow subjects, breakwaters and close-up views of architectural details.

Further examples can also be found on the beach, where boats with all their associated tackle and jumble make wonderful subjects. Farms too are very rich in such material, and often one finds all manner of items and implements nicely stacked and conveniently arranged. As such subjects really become very large still-life groups, it is proposed to deal with them more fully, under that heading, in the next chapter. However, they serve as a reminder that here the greatest concern for the effects of space and volume is concentrated on the main group. As with all other paintings the need to maintain a balance remains but here it is adjusted to give the background very little emphasis. Or to return to photographic terms, the background is now decidedly out of focus.

The third type of foreground, and in many respects the most difficult, is the one that is very empty and so large that it occupies by far the major proportion of the canvas. An example of such a scene is *Colour Plate 32*. It may be argued that the inclusion of a well-sited fence, a post or perhaps a figure or two, would be helpful, but let us assume that the strange sense of emptiness was the real attraction, which would have been destroyed by these usual aids to composition. The choice of such a subject is similar to choosing a composition in which a large area of sky is the main feature, though in this instance it is the lower and not the upper part of the picture which holds one's interest. Continuing with this imaginary change-over from sky to land, the answer becomes clear. It was reasoned earlier that if

the sky held more interest than the earth, then it should occupy the greater area; so far so good, for with large foreground paintings the earth occupies a decidedly larger area than the sky. When choosing to paint a large sky it was also observed that its real interest lay in the fact that it contained so much movement, pattern, change of colour and a feeling for considerable qualities of recession. Furthermore such changes of tone and colour were not harsh or sudden, violent or sharp. If one takes what has been prescribed for the sky and relates it to the painting of this big area of land, one has the formula for the successful handling of these large and difficult foregrounds. First, the eye must search for any change of colour, any variation in tone, which helps to break up uniformity and thereby creates a gentle and subtle hint of pattern which will be just a little more pronounced in the areas which are nearest. In the furthest areas the colour will be more general and evenly painted, but as the distance decreases the changes of colour, although by no means sudden, will become more and more vigorous. The usual care must be taken not to indulge in any fierce emphasis in the more immediate foreground for fear of drawing attention to the wrong place. In such a scene it is essential that the eyes should be led into the picture and not come to rest along the bottom edge. To avoid this it is a very good plan to make the base of the painting start at a point some ten feet away from the easel.

Foregrounds are always difficult to get exactly right; they cannot be set into hard and fast categories, nor is there any rigid set of rules for their success. With knowledge and experience one can break through the generally accepted guide-lines. The important thing is to know these guide-lines, so that when any personal interpretation is sought or rule is broken it is done not by accident and through ignorance, but intentionally and with understanding.

13 The Value of Still Life

The study of still-life painting can easily become a quite distinct and separate branch of art and, in the hands of a master, can result in work of exceptional depth and quality. If anything that is written or illustrated in this chapter should encourage readers to make still-life work a specialized study, I shall be delighted. The real reason for its inclusion, however, is the belief that the study and practice of still life, although an end in itself, will surely improve painting standards, irrespective of subject matter and in whatever style. With possibly the single exception that there is less need to express great distances, it contains every challenge that will be met in any other type of work. Form, tone, colour, composition and even perspective and recession will all be present.

There are those who neglect still life completely, discarding it as being either a boring activity or a mere five-finger exercise; an attitude which I can understand, but with which I strongly disagree. Those whose time is limited may well feel that to indulge in another branch of painting, when they have little enough time to give to the study of the landscape, seems rather like suggesting a change of horses when they are not yet in control of the one being ridden. The truth is that such a change may well be the equivalent of providing a much less worrying ride and of teaching a great deal that will be of use on return to the original mount.

The charge of boredom is usually an unsubstantiated one, made by those who have not tried working from still life. They somehow think it will not hold their interest, but those who apply themselves find it most absorbing, for not only can it result in work that is pleasing and original in its own right, but it is also rich in information valuable to all other paintings. A local Arts Council once asked me to run a short painting course for a few hours a week for eleven weeks. As it was held during the winter months, the study of still life became an important feature. The group prospered and the eleven weeks extended into several years. Good-natured sighs and exaggerated expressions of misgiving were heard as each arrangement was first set up, but as soon as work progressed people were loud in their claims, often expressed with surprise, of how interesting and

absorbing was the 'exercise'. Almost everyone stated how it helped in the appreciation of things previously ignored or not properly understood.

Consider some of the advantages. The still-life group can be set up in a convenient corner where the light is static and unchanging. In consequence the artist has much more time to come to grips with the problems of matching tone and tint with accuracy than can be spent on other types of painting. He does not have to memorize transient and fleeting effects of lighting, as is so often the case in landscape work, nor will some sudden change of weather call a halt, dampening both him and the inspiration. All materials are to hand, and there is no frantic packing up session for, providing the necessary cleaning is done, everything can be left for a further session of work the next day or the day after. Problems of composition are easier too, for modifications and changes can be factual rather than imaginative and it is a simple matter to change the arrangement until it is suitable. All these factors help in producing a more relaxed and thoughtful attitude with plenty of time to concentrate on essentials and continually to compare the painting with the completely unchanging original.

As in all forms of picture making, composition plays a most important part. For this reason it is far better to gain experience in arranging your own group rather than settling for one that has been arranged for you. A good idea is to collect about eight or nine objects and to experiment with making pleasing arrangements by using only four or five (see *Figure 37*). It matters little what the objects are, provided there is some variety in their height, shape and texture. As far as colour is concerned, one can either opt for things which are in the same family (for example, variations on browns and ochres), with the occasional accent on something quite different, or one can choose objects of varying colours, providing the changes are not so strident as to be offensive. Try not to be too ambitious; just as the raw beginner to landscape painting usually wants to attempt a scene whose content and lighting would have perplexed both Turner and Constable, so the newcomer to still life usually tries far too hard by including a surfeit of objects grouped in a most complicated fashion. He will cheerfully try copper pots complete with reflections, backed up by dusty grapes, a dead pheasant and a large intricately moulded and decorated piece of pottery. All of this would take so long to draw that it would be difficult indeed to avoid a severe bout of frustration. Far better that the objects should be reasonably simple so that interest is gained not only from the quality and individuality of the painting, but also from the play between the texture of an object, its form, its light, shade and colour, and its interaction with those of the other objects in the group.

With still life, many of the same rules of composition apply as were outlined when dealing with outdoor scenes, but possibly it is even more important for the component items occasionally to

overlap and partially obstruct the view. It is always possible to make exceptions, but to have the various objects in a regimental row, or to have them dotted around like isolated islands in a sea of background, is seldom satisfactory. Once you have your group arranged to your liking, take up your sketch-pad to see how it looks when placed within a rectangle of the selected proportions, for often, even at this stage, slight modifications have to be made for it to sit comfortably within its given boundaries. Failure to do this often culminates in the finished painting having to be trimmed to some unusual shape or odd measurement. Although this kind of salvage operation can occasionally be successful, one should hardly start a painting with the idea that in all probability a certain portion will have been carefully worked at merely to finish up in the nearest waste-bin. It is better by far that it should compose correctly at the outset. What I suggest is that you look at the group and, mentally, stretch a thread from all its projections. You will then have a strange abstract shape similar to the one shown in

Figure 37 These compositions were made by arranging a few objects from a wider collection – a helpful exercise which is more constructive than working from a group arranged for you.

Figure 38. Draw this shape on your pad first and then place the correctly proportioned rectangle around it, endeavouring to make it of a size which strikes a pleasing unity with the dimensions of the thread-encircled group. It may take two or three attempts to get it right; it may mean a slight rearrangement of the group or a minor change in the siting of the easel, but it is not a lengthy business and will be quicker by far than finding all is not well once paint has already been committed to canvas. Corrections at such a late stage are very frustrating.

Having arranged the group and decided how it will be positioned on the canvas, the painting can proceed in the usual way. In my example, shown in *Colour Plate 33a*, the group was first arranged as prescribed, the only change from the original idea being the inclusion of a few laurel leaves as there seemed to be a gap near the centre. Although there were a lot of quite interesting folds in the draperies at the back and on the table, I decided to underplay these to give the grouped objects a greater dominance. The first stage was to draw the group in pale outline and although care was taken with the proportions I did not worry if the drawing was slightly awry, since minor deficiencies could be corrected as the painting proceeded. Then, using no white but merely colours thinned with a little turpentine, I attempted to establish the essentials of the group, taking care to search for the darkest areas and to put them in first. At this stage it is always surprising how quickly things begin to take shape, which confirms that to register the darker areas will quickly give form. Then, merely by decreasing the pressure on the brush, the middle tones can be indicated and finally the

Figure 38 An imaginary thread placed around a group will help place the group satisfactorily on the canvas.

lighter areas. No white paint was used at this stage, for the light patches are suggested merely by having the paint so thin that the white board or canvas shows through. When completed this stage should look like a rather hazy view of the subject; almost as if it were seen through frosted glass.

The next stage (*Colour Plate 33b*) was to go all over the work with slightly thicker paint, being much more careful with the mixtures. Again, it is a wise plan to establish the darks in a general way. Once this has been done I usually try, as far as possible, to work from far to near, so now was the time to paint in the background. The method is very similar to that employed in landscape work and it may be interesting to record that exactly the same range of colours was used as those recommended for the outdoor scene. Colours had to be carefully assessed when mixing, and I found the grapefruit needed great care for its colour was a faintly greenish yellow which had to be slightly different from the more ochre-yellow of the adjacent straw-covered Chianti bottle. A little too much yellow would have been too fierce; a little too much green and the grapefruit would have changed into a large cooking apple. Notice also the slightly grey-purple content in all the shadows. The final point to remember at this stage was to paint very gently one area into another, thereby preventing any offensive hard edges which can so easily make things look rather like cardboard cut-outs.

The final stage (*Colour Plate 33c*) entailed going all round the painting once again, correcting the drawing and including any little extra accents, or suggestions of detail, that would be helpful. It is important at this juncture not to get carried away and become too fastidious for this will give a very 'tight' result, lacking atmosphere. So great care was taken in suggesting the plaited nature of the straw handles, the flat straw on the bottle, and modelling on the leaves. I tried the whole time, but particularly in these later stages, to remain aware that there was space between myself and the group and I endeavoured to maintain this feeling for such a distance in the painting. Lastly, in went the pure, crisp highlights.

Such was my own interpretation of the subject, but one of the greatest delights in painting is that no two artists will translate the subject in exactly the same way. Just as in language, once the basic structure is understood, the same story is capable of being told with an infinite variety of expression and vocabulary. The painting may be expressed in a high or low key, with a personal interpretation of colour, with a very loose and nebulous touch, or with a firm and definite accent on the qualities of pattern. It may even stress the reality of the subject to such a degree that it almost looks as if the objects are so real one could pick them up. At its best such a style must be admired for the considerable skill, observation and craftsmanship involved, but it should really only be attempted after such knowledge and expertise have been carefully controlled. It is wiser, I feel, to retain your individuality by developing a more personal style

Figure 39 Still life has many strong links with landscape work, as is clearly evident from strong similarities in these two sketches.

built on the generally agreed foundations, and to leave the highly photographic approach for something in the nature of a very challenging exercise.

Throughout this chapter the strong links between landscape work and still life have been stressed, because although a picture made from objects near to hand may relieve us of the need to suggest vast distances, some feeling for air and space is still necessary. For this reason the careful study of still life will prove an invaluable aid when foreground features need to be included in a landscape. In many other respects the links are also close, as can be seen in the sketch in *Figure 39* where the grouping and massing of the still-life group and that of the landscape study are decidedly similar. The greater recession in one is the only real major difference.

Now a few hints. If you arrange a group and suddenly whip away the background material and change it for one of a different tone or colour it is most surprising how it transforms the group. Bearing this in mind it is a good idea to have some odd remnants of materials of various colours tucked away somewhere or, failing this, to keep back a few sheets of pastel paper which come in many delightful 'quiet' colours suitable for creating a background. All manner of objects and odds and ends that are paintable can be collected, for these too help in setting up groups on winter days when outdoor excursions are impossible. Bottles are marvellous, with their strange colours, pleasing shapes and unusual reflections. Stone jars and unglazed pottery are very good too and, in spite of previous wariness, one can often make use of the odd piece of copper. Fruit too is useful, but as one can hardly keep it for long I have produced some very passable substitutes from modelling clay which can be brought out at any time. It is possible to get some very good professionally made artificial objects; my greengrocer showed me a string of plastic onions which defied all detection by sight. There are also very clever leaf sprays made to help those who indulge in display work. No doubt you could add to the list but such things, if collected at odd times, can save considerable time when the still-life session is being planned.

Although I have recommended that it is better, if possible, to set up your own group as this will help you to think in a

painterly way, occasions will often arise when a very suitable group can be found ready-made; various objects have been put down at random, usually for quick convenience, and quite by accident they make an admirable composition. Such arrangements are most frequently found in such places as the garden-shed, the work-room bench, the kitchen, a corner of the studio or the greenhouse.

A still-life group need not always be restricted to small items, for an arrangement of large objects can be equally effective in making a pleasing picture. This is more likely to be found by chance; one could hardly heave around such things as barrels, abandoned farm implements or piles of timber in an attempt to arrange them into a suitable composition. Providing they compose themselves well and sit happily within the picture area, the fortuitous collection of larger objects retains much of the qualities of the more normal still-life group. The only real difference is that, because they are likely to be outside, the lighting cannot be as controlled and constant as in the studio-piece and the artist must to a certain extent rely on memory for maintaining a grasp of the most telling lighting effects. A good example of the subject found by accident is shown in *Colour Plate 34*. I was painting an outdoor scene near Teignmouth in Devon, when an extremely fierce and bitterly cold wind suddenly swept down the estuary. A very kindly boatman unlocked his shed with the idea that work could continue by taking in the same view from his window; a most hospitable gesture. As I entered, however, there against the back wall was a wonderful collection of chandlery, so I immediately changed plans and settled down to paint this large still-life group. Apart from placing the white oil-stove a little further to the right, hardly any changes in the composition were necessary and I spent a very happy afternoon endeavouring to capture the soft lighting that so gently illuminated this pile of delightful jumble.

Other variations on the large and accidental arrangement can be found in the open when searching for the more conventional landscape subject, and I usually refer to such a subject as an 'outdoor still life'. It has already been stressed that the best view is usually found after a little exploration and during such reconnaissance forays one is often presented with superb examples of these larger compositions which would have remained hidden during a more casual survey. So on your meanderings around the possible painting sites keep your eyes well open for these outdoor still-life groups. Farms are a rich source of such material, for with so many odd corners to negotiate and so much related paraphernalia on display, one is constantly presented with a wealth of subject matter all beautifully unified by wind and weather and linked by a sense of common purpose. Such things as wooden tubs, wheels, fencing, bales, poles and drums all combine to make groups that could hardly be bettered were they arranged with deliberation and intent. Occasionally one may feel a need to make slight

changes, but this is a simple matter and can be made when working on the preliminary sketch.

Builders' yards are also interesting for they too are rich in subjects with a pleasing mixture of items all relating to a broad common purpose; planks, posts, tanks, tiles, piles of sand, ladders and sheets of roofing. And for the same reasons the gardeners' area is always popular with painters. My own example of an outdoor still life (*Colour Plate 35*) was painted from a very quick 'lay-in' and a series of rapid sketches and notes made when a variety of objects were quickly put to one side during the erection of a new fence. It was the beautiful colouring of the timber in the old fence plus the arrangement of the scattered materials in front of it that I found so attractive. Even the rather forlorn pot-plant was there and the only real change made was the placing of the bright green can, which originally was not quite in the picture.

I trust this chapter has convinced readers that working on still life should never be boring. Practised at regular intervals it will provide all the answers to all the problems found in every branch of painting and at the same time result in work which is deeply satisfying and beautiful in its own right.

14 Painting Flowers and Plants

Life would be dull indeed without the cheering and decorative influence of flowers. They grace our landscapes, enrich our gardens, brighten our rooms and, when compliments need expression, they become articulate messengers bringing pleasure not only to the sender and recipient alike, but also to all who see them. Their fleeting qualities seem to capture all the joy of the current season and are a reminder of the continuity of Nature's pattern. With the grace of their structure, the brilliance of their blooms and the rich contrast they make with surrounding foliage, it is hardly surprising that flowers present the artist with a rich variety of subjects which, although challenging, are deeply satisfying.

What makes the flower study so challenging? Confronted by a cluster of flowers all the usual problems of selection and interpretation are presented to the artist, as in any other subject, but in this instance the challenge is increased by the almost frightening abundance of so much that is beautiful. Such a surfeit of good things can easily lead to a conflict of interests which if not properly controlled, can result in uncertainty and a lack of direction in the finished painting. Evidence of this conflict is apparent in so many flower pieces seen at various Art Societies, in the detailed over-emphasis of almost every blossom, bud, twig and leaf. In such works each bloom, whatever its position, receives exactly the same treatment and appears to receive exactly the same amount of light; in consequence the unity and the rotundity of the group is lost. What is needed is the ability to underplay those passages which are more distant, or are less well lit, and the complete group will then look less like a flat pattern and more as if an insect could crawl or fly around the various masses. A careful but overall look at any group will usually reveal that only one or two blooms receive the greatest light and appear to nod their heads forward; the remainder stay in partial shadow or fade discreetly into the background. Such is the essential quality to bring to the painting, and unity and form will then be preserved. Additional texturing and finer details can then be included, with discretion, and all will be well. To work hard giving the 'full treatment' to each and every item not only spoils the very

essence of the group, but is liable to produce brittle, hard and almost metallic flowers that would break rather than bend and would certainly never suffer the indignity of wilting in a few days' time. And so, through being so very conscientious, the artist loses the ephemeral qualities as well.

Imagine for a moment that, during a walk around the garden, you have come across a growing group of roses very similar to the one shown in *Colour Plate 36*. You would, at first glance, be immediately appreciative of the richness of the colour and the way the blooms catch the light and are thrown forward by the pattern of the leaves and the deep caverns of darkness behind them. The overall shape and pattern of the group would also be particularly attractive, as would the pleasing tracery made by the topmost twigs, leaves and buds. So much for the first impression, but because the group would be in such close proximity and because Nature is so benevolent, on closer inspection more and more beauty would be apparent. This closer scrutiny would disclose such things as the pattern of leaf veins, the serration of leaf edges, the little whiskers around the buds, the formation of thorns, the design within the petals and even the nature of any other type of adjacent growth or background foliage.

This is the dangerous moment: time for the artist to endeavour to create a mental image of the painting-to-be. Such an image should capture the all-embracing unity of the first impression and also include, from the second and more detailed inspection, only those items that help make the work more meaningful, acceptable and artistic. At the same time, consideration must be given to the artist's personal style and to the medium being used, for what may come very easily and freely to one hand may well become laboured and stilted when attempted by another. By the same reasoning what may well be achieved with ease and artistry by a line and wash technique, for example, may be almost impossible when working with the more opaque, thick and butter-like qualities of oil paint. An example of a subject more suited for line and wash is shown in *Colour Plate 37*.

It is all too easy, after making a close inspection of the subject, to fall so much in love with the detail that the resultant painting increasingly takes on the character of a botanical study and thereby becomes less sympathetic to the subtle effects of lighting and the possibilities (and the limitations) of the medium being used. This does not mean that all botanical studies are artistically unsound, for that would be an overstatement, but the vast majority are produced mainly for recognition and research rather than for aesthetic appreciation. The botanical illustrator places his greatest accent on indisputable facts and accurate details and has much less consideration for such things as depth, mystery, lighting and transience. With the artist this order of things is reversed for he is only concerned with such details as give his work credibility and structure, and

his main aim is to create a living picture which at one and the same time characterizes the quality of his subject, explores sympathetically the possibilities of his materials, captures the quality of light and also gives scope to his own personality and individual style.

Whilst building up this mental image of how the finished painting will appear, the usual tenets of composition must not be overlooked. They remain very much the same as for landscape and still-life work, with the possible exception that, due to the close proximity of the subject and the upward nature of the growth, the vertical composition will often be much more acceptable. However, even with the vertical composition, it is wise to avoid an arrangement which savours too closely of symmetry for this is out of keeping with the natural appearance and growth of most plants and immediately strikes a false note. The improvement made by allowing the arrangement to be somewhat uneven is shown in *Figure 40*. The same can be said of an arrangement which presents a very flat silhouette around the edges (particularly the topmost) or one which has within it any suggestion of a disproportionate amount of repetition (see *Figure 41*). In such cases a slight rearrangement or a change of viewpoint will usually set things right and bring about a more natural and satisfying composition.

Fortunately, with floral subjects, the need to ensure that certain parts of the group overlap and partially obstruct the view of others is already done for us either by the accident of arrangement or by the intricacies of natural growth. However, the need should not be forgotten, for a solid area of uninteresting foliage can often be greatly improved by carefully placing in front of it a blossom or a leaf or two of a lighter colour. This will not only help to give a better pattern and a greater contrast, but will also create an extra plane which, in turn, leads to a greater feeling for volume and depth. There are also occasions, particularly when the flowers are in a vase, when each stem, quite by accident, becomes separated from its neighbour, with the result that they all radiate from the container rather like the supports of a fan. Under such circumstances it is almost impossible to

Figure 40 With flower subjects it is best to avoid arrangements which are almost symmetrical.

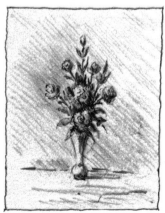 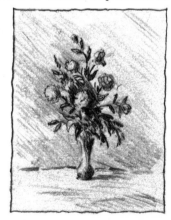

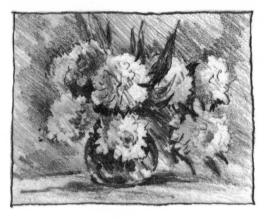

Figure 41 An irregular silhouette is more natural and effective than one with very straight edges.

give any sense of distance or volume to the group, and some form of overlapping is clearly necessary. The rather glorious confusion that results when certain areas become dense and closely packed provides us with delightfully mysterious passages giving considerable scope for personal interpretation. The gradual separation which occurs towards the top of most flower groups also provides a pleasing contrast between the areas which are fairly solid and those through which the background can, intermittently, be seen.

Figure 42 The central stems of leaves are seldom straight and rigid. As can be seen here, a curved stem quickly establishes the natural growth and twisting nature of leaves.

135

Figure 43 It is usually better if the vase occupies a smaller area than the flowers.

The vase, pot or container, which is an obvious necessity unless one is painting the flowers as they grow, can often offend by occupying too large a share of the picture area. A vase that is rather large, although quite acceptable in a spacious room, can easily be far too dominant when the whole group is transferred to the confines of a canvas. The best advice is surely to keep it as small and insignificant as possible without allowing the composition to look top-heavy or ridiculous. If a physical change is not possible, the vase can often be reduced to a more acceptable size when making the preliminary drawing (see *Figure 43*), but it is obviously better to try to have all things right at the outset. Over-dominance by the vase can also be avoided by ensuring that there is sufficient volume in the arrangement of the flowers for parts of them to project and hang down, so that a little of the vase is obscured, as shown in *Colour Plate 38*. If this idea is combined with a fairly strong top-and-side lighting, shadows will be cast. These create extra shapes and patterns, always helpful in breaking up large masses, and also serve to link up and unify the whole composition. Another idea is to place the group well below eye-level, for this, as well as presenting an interesting view of the flowers, will also partially obscure and foreshorten the container and thus prevent it from hogging too much of the viewer's attention.

Those who indulge in the more formal and stylized type of flower arrangement have helped the artist to avoid the over-dominance of vases by the introduction of such aids as 'pin-holders' and blocks of water-absorbing plastic, which will support quite long stems from their base. By such means an arrangement both wide and tall can be contained in quite a shallow bowl or dish. Whilst grateful to the flower arrangers for their 'mechanics' I confess that, much as I admire their meticulous arrangements in the right setting, I find them very difficult to convert into paintings. I am not entirely sure why this should be, but I think it must be for the same reason that most artists find it difficult to paint beautifully landscaped and formalized parkland. They seem to be very much happier when patches of natural and undeveloped areas present themselves.

For me the cottage-type, domestic flower group is eminently more paintable, giving greater scope for variations and personal touches.

Potted plants are a favourite subject and although care must be taken with certain varieties, such as chrysanthemums and many of the daisy family which can be rather flat along the top, most of them make fine subjects. Equally pleasing can be the pot itself, particularly if it is a genuine earthenware one, for its texture, its weathering, its shape and its rich terracotta colour are very paintable and beautifully in harmony with the majority of plants. Should the pot seem a little large for your purposes, a good idea is to include some crumpled wrapping paper, usually coloured tissue, which will both camouflage and complement the container (see *Figure 44*).

There is of course no reason why the vase or pot should always be included and many highly successful paintings have ignored the pot completely. In many such works there is little or no silhouette and the pattern of blooms and foliage extends beyond the edges of the canvas, so that the whole of the picture area is one glorious mass of design and colour. Such a subject can be selected from many internal arrangements and is also particularly successful when working out of doors direct from the growing plants. The problems for the artist are no greater than in other arrangements with the possible exception that it is particularly important to maintain a sense of depth. This usually means taking extra care in establishing the strong hollows of darkness and especially the slightly greyish hues of the more distant items, for if these are interpreted correctly the more obvious lighter and purer colours fit into place with far greater ease. Often we are so attracted by the more brilliant

Figure 44 Wrapping paper was used in this arrangement.

137

hues that we fail to appreciate that it is really the darker colours adjacent to them that make them glow.

Whenever possible paint flowers whilst they are still growing, for there is no finer way of capturing all their freshness and charm. The turpentine-laden atmosphere of the studio is left behind and I can think of few activities more pleasant than sitting quietly in the garden selecting, enjoying and painting a mass, or a spray, of favourite blooms and foliage. The choice is wide, but plants of the clematis family are a firm favourite, as are the multicoloured and graceful irises. Large, decorative poppies, because of their fresh colouring and the way they vary in shape, also make a most pleasing subject. Unfortunately their life-span is very short (only a day or so) and for this reason one has to 'lay-in' the position of the blooms very rapidly. This is essential, and quite exciting, for there are seldom two heads exactly alike. At the completion of the study there are usually just one or two lonely ones remaining to serve for colour reference, whilst the buds of those yet to bloom help to make a pleasing contrast. Roses too are eminently paintable, as are chrysanthemums, dahlias and hydrangeas. In fact there is something for all tastes and all seasons. An additional benefit of the outdoor subject is that there are usually plenty of other plants and bushes behind the chosen study, normally conveniently out of focus and very useful in creating a sympathetic background.

Whatever the location of the subject, the background is always important and be it bushes, a wall or a drapery, its general tone and colour must, in addition to being harmonious, be such that it never obtrudes; its job is to stay well back. The background may be light, medium or dark, but the colour will never be fierce or strident so that it jumps forward and claims undue attention and becomes as clear as one of the nearest features of the group. A severe test that illustrates this point is to place a well-lit white flower only a hand's breadth away from a white wall. It will then be observed that the lightest part of the bloom is whiter than the wall whilst the part in shadow is decidedly darker. Were we to make the wall pure white, it would be impossible to indicate the form and volume of the bloom.

Before starting to paint flowers it is prudent to give a little thought to the need for a few extra colours. The normal range which has served well for landscape and still-life studies may not be quite sufficient to produce some of the more brilliant colours needed for flower painting. Some of the reds and purples, for example, would be very difficult to mix and a few extra colours on hand would be helpful. Some very useful additions are listed below:

Permanent Rose	Lemon Yellow
Burnt Sienna	Monestial Blue
Magenta	Cerulean Blue
Purple or Violet	

The inclusion of Purple and Magenta can save a lot of frustration with such flowers as anemones; the Permanent Rose and Burnt Sienna in conjunction with the two reds already in the palette will help with many of the more subtle reds and pinks; the extra yellow too can help with such flowers as daffodils, but take care for it can easily produce a very sharp and 'acid' effect, particularly when used for making green. The Monestial Blue is a very powerful colour but can be put to good use, not only as a blue, but also for making very rich and powerful greens, whilst for quieter mixtures the Cerulean Blue is also a very useful addition. It would seldom be necessary to put out all these extra colours at one time; they are merely reliable reserves ready to be brought into play according to the demands of the subject and can either become substitutes or additional members of the team.

The painting of the clematis shown in *Colour Plate 39* is a case in point, for Cerulean Blue and Burnt Sienna were added to the palette to help in making many of the quiet and mushroom-like greys which were an essential part of the attractiveness of the subject. This painting, together with many of the other original flower paintings shown in this chapter, is done by my wife, Theresa, who has made a special study of plant and flower painting and whose help has been invaluable. The first stage of the painting, which was made in the garden (see *Colour Plate 39a*), was made in much the usual manner. After a few trial sketches a very weak outline was put on to the canvas to establish the general design. This was quite quickly 'stained' with colours weakened with turpentine, particular care being taken to establish the important dark areas, for in many instances these created the shapes of the flowers. If any light areas became sullied or too casual these were carefully corrected by wiping out with a rag.

The second stage, seen in *Colour Plate 39b*, shows how the building-up process uses the first stage as a reference to improve on both the drawing and the colouring whilst at the same time working mainly from far to near. This is very evident in the right-hand area where, although the leaves are becoming more recognizable and slight shadows are indicated on the petals, most of the pure white areas are still the bare canvas of the very weak underpainting. Thus the complete picture was worked over carefully, the artist avoiding the temptation to get carried away with some captivating passage, thereby giving it so much detail and finish as to be out of keeping with the rest of the work. Again the rag was put to good use to wipe out any incorrect passages, for the correction could then be painted on a reasonably clean canvas and the purity of colour, which is so essential when painting flowers, could be maintained.

In many ways the final stage (*Colour Plate 39c*) is the most difficult for it is very easy to become over-conscientious and to burden the subject with far too much detail. For this reason it is most important to keep firmly in mind the general view that was

the initial attraction. If this is retained, the last stages are a matter of subtle corrections, careful building up and a gradual improvement of drawing, all of which must maintain the essential qualities of form and lighting. It was at this point that the very delicately toned shadows were included, the twiggery and all the 'squiggly bits', with one eye on the needs of reality and the other on the personal demands for decorative qualities. Finally, a last look round for any highlights and then, with great deliberation, the brush was laid aside.

Between sessions of serious painting it is always a good plan to spend a little time on some careful drawing. What I have in mind is something similar to the drawings shown in *Figure 45*. Although one would never wish these to become tight, hard and metallic, a little more care can be taken than with the very rapid preliminary sketches. It is a marvellous training both for eye and hand and cannot be anything other than beneficial when a return is made to working with paint. The pencil has its own potentialities and limitations, and these need to be considered and understood – one is now working with hundreds of lines rather than in solid patches. But the links between drawing and painting remain very close. It is the control and facility such drawings bring to our dexterity and observation, however, that is their main recommendation.

Flowers whose blooms are very brilliant and intense in their

Figure 45 Occasional careful sketches help to improve observation and give control to the hand.

colouring always bring problems, for it is so easy to be carried away by their radiance that the fact that some are more brightly lit than others can easily be overlooked. Should this happen the complete group becomes flattened and rotundity and spatial effects are lost. Anemones, because of their brilliant and penetrating colours, make us particularly vulnerable to this temptation and in the example shown in *Colour Plate 40* very great care was taken to maintain a sense of depth and volume by 'fading-off' the blooms and leaves that were a little further distant, even though it was a matter of a mere hand's width. This is particularly evident around the top and at each side. Care was also taken to ensure that any petal or leaf (or part of them) which appeared to project forward was painted with a colour which was both light and clean. And, of course, those all-important caverns of darkness were carefully stated for these are essential in creating a feeling of depth.

Two more points about *Colour Plate 40* are worth a mention. The first is that, with help from the soft and absorbent support familiar to most flower-arrangers, the group composes quite well without the aid of the ubiquitous vase. The shallow dish in which they are contained is so shadowed that it is completely out of sight. Secondly, anemones provide a very good example of the need for additional colours. Without the introduction of the Permanent Rose, Magenta and Purple it would not have been possible to make such vibrant colours. A little touch of Lemon Yellow was also used to make some of the rather sharp greens. Great care must be taken, however, as it is so easy for this type of painting to present colouring that is hard, sharp and 'acid'.

One final point I wish to make on the subject of flower studies: it is wise, particularly before all the finishing touches are included, to stand back and quietly criticize the work. My own habit is to check that I have sufficient feeling for space to imagine a bee conveniently buzzing and flying all around it; should he be a shy bee, has he got some deep and shadowy areas where he could hide? Finally, do the flowers look as if they would bend in the merest ripple of breeze and have they that elusive but transient quality which tells us they are glorious today but will wilt in a few days' time?

But what, you may ask, of subjects which have no blooms and are composed entirely of a beautiful mixture of leaves, twigs and branches? All the usual principles of flower painting apply except that, because the subject will be mainly made up of hundreds of varying greens without the help of contrasting and complementary colours, it will probably be just a little more difficult. However, clumps of leaves, grasses, brambles and even weeds often make extremely paintable subjects, as can be seen in the painting, 'The Hedgerow' (*Colour Plate 41*). We had rigged up a temporary shelter from the rain and suddenly this composition presented itself, which proves that occasionally the subject finds you, rather than you having to make a lengthy search for the subject.

15 Presentation and Framing

The same care and thought that goes into producing a painting should be taken when choosing its frame, for the final presentation of a picture should be one of great unity. The frame is not just any old thing that is required, by convention, to surround the work; a frame is very much a part of the complete picture. A painting of only average quality, if properly framed, can look quite passable; the competent painting will look even better, whilst the work of a high standard will be complemented and enhanced. So take care with the framing.

The function of a frame is twofold. The first is to blend with the work in a happy neutral manner, thereby giving the complete presentation of a pleasing and harmonious finishing touch; the second function is firmly but gently to separate the work from its immediate surroundings, thereby preventing any distraction from such things as the patterned wall-covering or the nearby curtains. Indeed when a work is hung, it is wise to place it in an area as neutral and unpatterned as possible.

If you have a finished work that needs framing, the type of frame or moulding that would suit it best must first be assessed. If you are fortunate enough still to have an artist-framemaker in your area he will offer valuable advice, but unfortunately such talented gentlemen are now few and far between and usually frames have to be ordered through an agency or retailer and the craftsman who makes them is seldom seen. If such is the case, and no expert advice is available, you must try to view your painting dispassionately and decide on the most suitable type of frame yourself. There are exceptions to every rule, but in the main it will be found that oil paintings need a fairly wide and robust frame to enhance and blend with the boldness of the work. On the other hand the frame should never compete with the work by being discordant or over-dominant. It is interesting to note that a very small painting of 5in × 4in (13cm × 10cm) can readily accept a moulding of 2in wide (5cm), but one cannot merely enlarge on this proportionately. To do so would give a picture measuring a mere 10in × 8in (25cm × 20cm) a frame some 4in wide (10cm), which would be far too overpowering. It is not easy to generalize but for normal purposes a frame between $2\frac{1}{2}$in

and 3in wide (6cm–8cm) would be suitable for paintings measuring about 20in × 16in (50cm × 40cm).

There are five basic contours in the style and shaping of the moulding and the problem is to decide which one will be most effectively in harmony with the picture. These shapes are shown in diagram form in the top row of *Figure 46* and, for simplicity's sake, show no ridges, additional planes or decoration; they merely represent the basic shapes from which all variations of frames can be constructed. The bottom row shows possible modifications when they are converted into mouldings. The five basic shapes are:

1 Concave
2 Splay
3 Flat
4 Convex
5 Reverse

As it is often difficult to look at one's own work disassociated from the problems involved in its production, it is a good plan to view it from a distance greater than is customary. This encourages an objective view, almost as if it were the work of someone else. Propping it up in an unfamiliar place, or viewing it in a mirror may also help one to see the work as a whole without becoming too closely reminded of those passages which presented particular problems. The painting should be viewed with the eyes of an interested observer rather than with those of a loving parent in order to observe its truly salient features. It is the position of such masses, and the resulting centre of interest which largely decides which type of frame would best suit the painting, and the general feeling which is evident in the painting – one of receding planes, for example – should, to some extent, find an echo in the angles of a cross-section of the frame.

Figure 46 Whatever the type of frame, it is usually based on one of these five basic shapes.

143

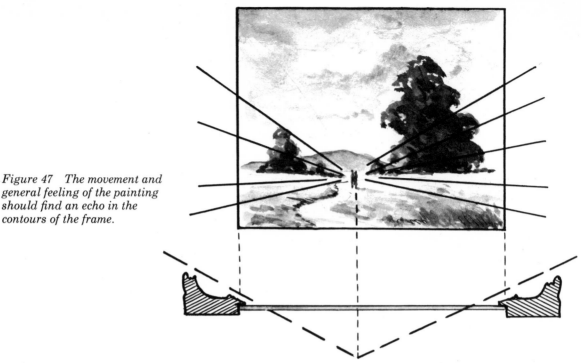

Figure 47 The movement and general feeling of the painting should find an echo in the contours of the frame.

In a painting similar to the one shown in *Figure 47* the viewer's eye is encouraged to wander deep into the picture; one can almost imagine a series of radiating lines converging at a point near to where the path disappears and where the figures are standing. The correct frame in this case would be one where the angle of the perspective lines is in sympathy with the angle of the face side of the frame. For this reason the concave shape would be ideal, to encourage the eye into the picture rather than tempting it, by some alien influence, to take a meaningless rectangular tour all around the edge.

This reasoning may suggest the splay shape as an equally effective alternative, but its very flat edges and sharp corners are usually considered more severe in character than those in a frame whose angles slope towards the picture in a gentle concave curve. For this reason the splay is much more suited to paintings that have rather hard edges within them. For work that has any affinity with Impressionism the splay is rarely suitable, but for works that are sharp and angular, having their roots in Cubism, such a moulding is an ideal companion.

Frames which are termed flat are rather rectangular and box-like in appearance and the major part of their surface is on the same plane as (or is parallel to) the painting surface. This makes them obviously more at peace with paintings whose subject matter does not disclose any great depth or recession. They can be suitable for landscape work when the foreground is really the main feature (*Figure 36b*. page 120, would be a good example) or for still-life subjects composed mainly of a closely seen row of

rather box-like or flat-planed objects. Many flat frames are now made from metal, and to avoid difficulties and expense these are usually made very plain and stark with none of the little ridges and changes usually found in the conventional wood and plaster mouldings. Their main attraction is their metallic finish and the complete uniformity of surface; with the right painting, they blend well and create a pleasing entity, though it is unfortunate that they have bouts of being fashionable and are often used with little concern for suitability or harmony with the work.

The convex frame and variations derived from it have an almost extrovert vigour when compared with the quiet dignity of those based on the concave shape. The lustiness of this type of moulding should be kept in mind when a more energetic style of painting is being considered. Palette-knife paintings, for example, would blend happily with a frame based on the convex contours.

Lastly we have the reverse frame, where the outside edge of the frame is closer to the wall than is the surface of the painting. This helps considerably in throwing the subject forward and is very helpful if the main area of the work is very much in the foreground. Such frames are invaluable for the displaying of portraiture, flower pieces and many still-life studies.

Having decided on the width and general style of moulding you require, the next consideration is the colouring and the amount of decoration. Too much decoration and intricate carving, although capable of holding our interest for its own sake, may well be so exciting that all attention is diverted from the content and quality of the painting. It is very disheartening if, after struggling with an ambitious and difficult painting, the very first comment made when it is proudly displayed is something like – 'Oh! I must say, that's an absolutely beautiful frame.' If in doubt keep the decoration discreet and simple, for the border lines made by the various ridges and hollows will often be quite adequate.

As for the colouring of frames, it is worth remembering the general principle that similar colours draw attention to each other. I do not therefore consider it wise to pick colours that appear in the picture to repeat them exactly in the frame, for this encourages the eye to jump from one to the other and in no way helps towards a tranquil and meditative acceptance of the qualities of the painting. It is far better to give a hint of such colours, but very much quietened and neutralized. The quietest of the colours shown in the chart for making greys would be helpful at this point for I have always found that the quieter colours, be they light or dark, are very much better for framing purposes than those which are very pure, sharp or bright. Pure white is usually much too stark and clinical and looks best if confined to very fine lines and ridges, and the same can be said of the very brilliant silver or gold finishes. If a metallic finish is desired (for any of the main areas) this usually looks far better

and is less ostentatious if it has an 'antique' finish, which again makes it less strident in its claim for attention. Although a very dark frame is by no means unacceptable, it is certainly unusual and would need to be chosen with great care. In the majority of cases the most suitable colours are those of a fairly medium tone with occasional light accents, but it is quite possible to introduce a darker colour which is normally more acceptable if it is darkest near the outer borders with the tones becoming gradually lighter towards the edges of the painting. Highly coloured frames seldom work unless the painting in question is of a very decorative nature, in which case the elements of decoration may well extend into the frame.

As most artists eventually develop a fairly individual manner of painting it is quite a good idea to have two or three extra frames made in popular sizes that agree with your personal style. Keep your paintings to the size of these frames and you will always be able to hang them immediately they are finished. This not only helps you to appraise your work but often acts as a boost to morale by apparently improving its appearance.

Unless you are skilled with woodworking tools I would not seriously recommend you to make your own frames. It can be a very tricky business, and to cut eight perfectly fitting mitres is a task which can reduce the mildest artist to a state of fury, frustration and frenzy. Although I am a fairly competent craftsman, I find that I get so interested and involved when making frames that, although the results are satisfactory, I am usually forced to the conclusion that I have used up rather a lot of valuable painting time. If, on the other hand, you have both the time and the skill, quite successful frames can be made with a considerable saving in cash.

The simplest method is to buy, in long lengths, the finished moulding of the required shape and colour. It is then cut, mitred, glued and pinned and you have your frame. This sounds delightfully simple, but is in reality very skilled; and it is essential that you have the right tools and equipment. There are devices to help with cutting the mitres, but your choice must be one that is very much more sophisticated than the old-fashioned saw-block, which will certainly not be accurate enough for this purpose. After gluing, some form of clamp is necessary but there is no need for any wild expense, for one can be made quite easily from a length of tough string and a few rectangular blocks of wood. In *Figure 48* you can see such a clamp in use. After the joints have been glued with a good quality glue (not a contact-adhesive), the string is first stretched to remove any elasticity and is then tied tightly around the outside edge of the frame, making sure the knot is well away from any corner. The small wooden blocks are then placed between the string and the frame somewhere near the middle of each member. As these wedges are then, in sequence, gradually pushed towards the corners the string becomes tauter and tauter and the joints tighter and tighter. To prevent the string cutting into the corners of the

Figure 48 An effective but simple clamp can be made using blocks of wood and a length of strong string.

frame the ideal plan is to have the wedges forced so far along that at no point does the string touch the frame. One of the advantages that this simple old device has over many of the more mechanical gadgets is that the two wedges affecting any one corner that needs a slight adjustment can be slackened and a correction made prior to re-tightening. The clamping effect is so tight that the whole thing can be lifted and hung up to dry without any fear of movement and the work-bench left clear for the next job.

When the glue has dried the frame should be placed corner-wise into a vice and four long and very thin nails tapped in gently, two in each direction repeating the process for the other three corners. As a precaution to prevent any bruising it is a good idea to pad the jaws of the vice with a little felt; I also play safe by leaving the clamp in place until after the nails are home. Should the blocks prove an obstruction to this process they can be temporarily moved back a little. A final touch punches the nails slightly beneath the surface; the tiny holes are then plugged with a suitably coloured wood-filler.

Finally, and again only if you enjoy woodwork and have the necessary time, it is possible to build your own mouldings from stock materials obtainable at builders' merchants and do-it-yourself shops. These can be built up in an almost infinite variety of shapes and patterns but it is as well to look for sections that are fairly simple in form and that combine without looking too fussy. *Figure 49* shows some suggested modifications that can be made to the basic shapes previously

Figure 49 Simple mouldings can be created by assembling various pieces of stock materials.

discussed; these can then be glued and pinned into sensible but manageable lengths. They will need to have some form of finish and colouring which is far easier if done before the frame is assembled. The white plaster-type wood filler can be used, either glass-papered or left to give a variety of textures. Colouring should present no problems, for you can easily mix your own and, with the additional help from masking tape, aerosol sprays and rub-on types of tubed metallic finishes, all kinds of effects and harmonies are possible.

Whether you make or buy, remember that a really good frame should help and support the subject all the time. Its influence should encourage the viewer to look at and enjoy the painting – not the frame.

It would be wrong to finish this book without conveying my sincere gratitude to all the friends and colleagues whose company, influence, example, advice, encouragement, help and talent has transferred itself to these pages. May such qualities spread in ever-widening ripples of understanding to all who read and see what I have explained and illustrated, so that all your future work will not only be well painted but will also be beautifully framed and well hung. May your brushes never harden, your tubes never split, your enthusiasm never diminish and your work never displease. Happy painting!

Index

Roman numbers refer to text pages, *italics* to pages where illustrations appear, and **bold** to colour plate numbers.